Treason,
Rebellion
&
the Fight
for Reform in
Rhode Island

Rory Raven

Published by The History Press
Charleston, SC 29403
www.historypress.net

Copyright © 2010 by Rory Raven
All rights reserved
Cover images courtesy of Russ Desimone and Brown University.

First published 2010

Manufactured in the United States

ISBN 978.1.59629.959.7

Library of Congress Cataloging-in-Publication Data

Raven, Rory.
The Dorr War : treason, rebellion and the fight for reform in Rhode Island / Rory Raven.
p. cm.
Includes bibliographical references and index.
ISBN 978-1-59629-959-7
1. Dorr Rebellion, 1842. 2. Dorr, Thomas Wilson, 1805-1854. 3. Rhode Island--Politics and government--1775-1865. 4. Suffrage--Rhode Island--History--19th century. I. Title.
F83.4.R38 2010
974.5'03--dc22
2010039224

Notice: The information in this book is true and complete to the best of our knowledge. It is offered without guarantee on the part of the author or The History Press. The author and The History Press disclaim all liability in connection with the use of this book.

All rights reserved. No part of this book may be reproduced or transmitted in any form whatsoever without prior written permission from the publisher except in the case of brief quotations embodied in critical articles and reviews.

*Dedicated to the memory of
Thomas Wilson Dorr
A forgotten hero and
a man ahead of his time*

THE DORR WAR

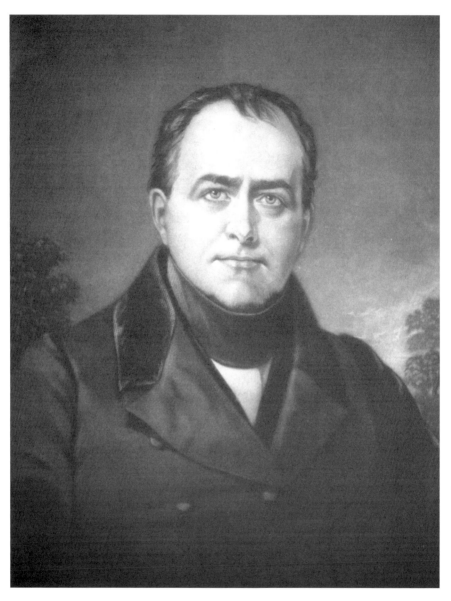

Thomas Wilson Dorr (1804–1854), the people's governor. *Courtesy of Larry De Petrillo.*

Whoever writes the history of these things, if he has an impartial temper, a quick eye for the ludicrous, and the power to see the cause of things in the things themselves, will furnish a most amusing and instructive chapter in the history of the times.

—*Abraham Payne, December 27, 1854*

Contents

Acknowledgements	11
1. The Charter	13
2. We the People	21
3. The People's Constitution	29
4. A Movement Against All Law	35
5. Algerine Law	42
6. The Two Governors	47
7. Unequal to His Situation	51
8. There Is Danger Here	57
9. Now Assembled in Arms	66
10. Acote's Hill	73
11. Algerine War	80
12. Probably to Inspire Courage	89
13. That Judicial Farce	94
14. An Effective Weapon in Political Warfare	104
15. That Ultimate Tribunal of Public Opinion	110
Bibliography	123
Index	125
About the Author	127

Acknowledgements

Nobody writes a book on his own. The following people were helpful in either tangible or ineffable ways. Many thanks to:

My wife, Judith, who puts up with a lot; Alison Bundy of the John Hay Library at Brown University, for her patience with endless "Oh, just one more thing" requests; the lovely Hannah Cassilly, my handler at The History Press; Erik J. Chaput, for discovering Dorr's Massachusetts arrest warrant; Dan Ciora, for untangling legal questions; Cirkestra, Emperor Norton's Stationary Marching Band, Jesca Hoop, Steve Martin and Carrie Rodriguez for supplying the writing soundtrack; Russ DeSimone, collector and expert on the Dorr War, who could have written this little book with one hand tied behind his back; the ever-supportive Larry De Petrillo, who has a picture of everything; Paul DiFilippo, for his enthusiasm from early on in the project; Dixie, for occasionally shutting up and letting me think; Jill Jann, behind me every step of the way; Edna Kent, for her time and information; John McNiff, for his expertise in antique ordnance; various members of the Providence Public Library's reference department, who displayed conspicuous valor, patience and general splendidness; Will Schaff, for help once again beating images into submission and continuing to be a good friend; Elizabeth Wayland-Seal, for kind encouragement when I needed it; Wilkie and Bellamy, because I haven't thanked them yet; Amara Willey, who long ago advised me to take on things I thought were slightly over my head so I could work up to them; and you, for being someone who reads thank-yous.

1
THE CHARTER

A band of armed men marched cautiously through the dark streets of Providence on a hot summer night. They wore no uniforms but the workaday clothes of laborers, millworkers and mechanics—men who worked with their hands and their backs. They seemed to be armed with whatever came to hand; some had rifles or pistols, but others carried improvised clubs or nothing at all. Some men at the rear laboriously towed a pair of antique cannon. The little army, about three hundred strong, was led by a portly man who limped along, sword in hand, urging his men forward. Calling them a ragtag band would almost have been a compliment.

They made their way through the streets of a residential neighborhood, houses looming up on either side of them. This was a good neighborhood, and these were houses almost none of these men could afford. At length, they reached their destination, an area of several acres' worth of open, grassy ground. Their target, an arsenal and the weapons stockpiled within, stood out in the humid fog a short distance away. The men fanned out and took up their positions, and the cannon were wheeled into place, loaded and aimed.

With a nod from their leader, one man dashed across the open ground to bang on the building's stout iron door, demanding the garrison's surrender in the name of the governor. A moment later, he ran back across to the attackers, shaking his head as he went. They had their answer.

Barking final orders as his men scrambled chaotically, their leader—Governor Thomas Wilson Dorr, a Harvard-educated lawyer and member of one of the state's oldest patrician families—must have

wondered how it had come to this, how he had found himself leading a dead-of-night attack on an arsenal.

He turned to the cannon crew and gave the order to fire.

The battle lines in what came to be known as the Dorr War had been drawn almost two centuries before and an ocean away. On July 8, 1663, King Charles II, newly ascended to the English throne, granted the colony of Rhode Island a royal charter.

Roger Williams, a Puritan radical and the Rhode Island colony's founder, had previously traveled to England to obtain a royal "patent" for his fledgling colony in the 1640s. Arriving during the chaos of the English Civil War, he was unable to meet with King Charles I, who was too busy losing to Oliver Cromwell, but he did manage to see the powerful Parliamentary commissioners for plantations. Williams's friendships with such Puritan luminaries as John Milton and even Cromwell himself probably opened some doors that might have otherwise remained closed. The patent the commissioners granted served as official recognition of "Providence Plantation" as an English colony, guaranteeing colonists "full power and authority to rule themselves and such others as shall hereafter inhabit within part of the said tract of land, by such form of civil government as by voluntary consent of all or the greater part of them." The king himself may not have issued the patent, but it was the next best thing.

Cromwell died in 1658. His Protectorate government collapsed, and the monarchy was restored when King Charles II took the throne on May 29, 1660, his thirtieth birthday. He and his new Cavalier Parliament quickly annulled the actions of the previous parliament, ordered the deaths of some of those who had deposed and executed his father, Charles I, and had Cromwell's body exhumed, drawn and quartered just for good measure.

This caused some concern across the sea in Rhode Island. With Charles II backdating official documents to show he had been crowned in 1649, directly succeeding his father and ignoring a decade of history, it was uncertain whether the new king would recognize the validity of a colonial patent issued before that time. And even if no one in the colony was running around punishing corpses, there was enough strife to go around. Unfortunately, the patent had not clearly delineated the colony's borders, leading to disputes with neighboring Massachusetts and Connecticut, both greedily eyeing the little colony's territory. It seemed wise to acquire a new document from Charles II, definitively establishing Rhode Island's status.

The Charter

Accordingly, Dr. John Clarke, the colony's agent and advocate in England, was authorized to obtain a new charter.

While Roger Williams is generally and rightly hailed as the state's founder, Clarke was no less important in Rhode Island's early history. Born in Westhorpe, Suffolk, England, in 1609, he was educated at Cambridge and later studied medicine, probably at Holland's University of Leyden, and was fluent in several languages by the time he arrived in the New World in 1637. Landing in Boston, he settled in Newport that winter, founding a Baptist church there in 1644 before returning to England with Williams to obtain the patent. Clarke stayed behind in London when Williams delivered the patent back to Providence.

Clarke's new mission was more successful than anyone could have imagined. The new charter—much of which may have been written by Clarke himself—was in many ways a remarkable document for its time. It acknowledged the "humble petition of our trusty and well-beloved subject, John Clarke," praised the "peaceable and loyal minds" and "serious and religious intentions" of the colonists and detailed a liberal and generous plan for "the free exercise and enjoyment of all their civil and religious rights." It established religious freedom in a phrase engraved today on the marble façade of the statehouse and which may have been lifted from Clarke's petition: "To hold forth a lively experiment, that a most flourishing and civil state may stand and best be maintained—and that among our English subjects—with full liberty in religious concernments." Such a startling declaration could get one hanged in the seventeenth century.

Local government was placed in the hands of twenty-six men, individually named and declared "a body corporate and politic, in fact and name, by the name of the Governor and Company of the English Colony of Rhode Island and Providence Plantations, in New England, in America." The charter went on to proclaim "that, for the better ordering and managing of the affairs and business of the said company, and their successors, there shall be one Governor, one Deputy-Governor, and ten Assistants, to be from time to time constituted, elected, and chosen, out of the Freemen of the said Company." It also called for twice-yearly meetings of a General Assembly consisting of

> *the Assistants, and such of the Freemen of the company, not exceeding six persons from Newport, four persons for each of the respective towns of Providence, Portsmouth, and Warwicke, and two persons for each other place, town, or city who shall be from time to time, thereunto elected or*

The Dorr War

> *deputed by the major part of the Freemen of the respective towns or places for which they shall be elected or deputed.*

In time, these assistants and deputies came to be known as senators and representatives.

The charter specified the rights granted to freemen of the company and set a yearly general election of a new governor and General Assembly on the first Wednesday in May. It also provided for the organization of a military and established the colony's borders, among other brass tacks. It really was a very progressive document for its time.

The charter arrived in Newport in November 1663 and was greeted with ecstatic celebration. Indeed, the charter became a kind of venerated holy relic, a ritual object. Each year, at election time, the outgoing governor humbly turned the charter over to the new governor, and the entire document was solemnly read out word for word before the hushed throng of freemen. Rhode Islanders were so enamored of their charter that when Edmund Andros, governor of the Dominion of New England, rampaged through the region in 1687, revoking royal charters as he went, Rhode Islanders hid their precious document from him and would not surrender it. Andros had to settle for breaking the state seal.

In 1664, the General Assembly passed an act limiting the right to vote on company and plantation business to the freemen, further stating that only property owners and the oldest sons of property owners were eligible for freeman status. Any adult white male over twenty-one years of age who owned at least £100 worth of real estate could apply for admittance to the company, which would vote on his application. If approved—and they seem to have always been approved—he and his eldest son were freemen and voters. In a time when most colonists owned land, this system offered most men the opportunity of entering the ranks of freemen—at least in theory.

Rhode Islanders held their charter in such high regard that it remained in effect into the 1840s, long after independence and by which time most other states of the union had adopted modern constitutions.

By the early nineteenth century, the royal charter was creaking under the weight of changing times. Some felt that the charter was antiquated and no longer served the population as justly as it once had, and they urged the General Assembly to follow other states' leads and draft a new constitution.

The charter's growing number of opponents made several specific criticisms, chief among them being the limitation of voting rights to the freemen.

The Charter

In seventeenth-century Rhode Island, land had been plentiful and easy enough to obtain, and most white men owned the requisite one hundred pounds of property. Even when the General Assembly raised the amount to £200, and then some years later raised it yet again to £400, this did not seem to present a serious obstacle to those wishing to become freemen. In 1762, the General Assembly magnanimously knocked off a zero, lowering the minimum requirement to £40. By the 1840s, when the tensions leading to the Dorr War were mounting, £40 pounds was equivalent to $134.

Samuel Slater opened his Pawtucket mill in 1793, sparking the Industrial Revolution and changing the Rhode Island economy forever. There had been attempts at working the land, but the thin rocky New England soil was poor, and most people either gave up attempts at farming altogether or moved west to try again somewhere else. Slater and his Arkwright machines put the final nail in the coffin of Rhode Island's early farm-based economy as many rural inhabitants turned to millwork instead. The cities grew and grew as industrialization boomed, and the local economy moved from agrarian "plantation" to an urban, industrial one. By the 1840s, the state hummed with the sound of dozens of mills scattered across the landscape. The many mills required a seemingly endless supply of workers, and then—as now—recent immigrants proved to be a ready source of cheap labor.

The Irish began to arrive in large numbers in the 1830s, and the next decade would see a huge influx of new arrivals. Some sources claim that in the 1840s, half of all immigrants to the United States were Irish. Many came to New England, sought work in the mills and lived in near poverty in three-decker tenements in the cities. They were not landowners and so were denied the vote. It is estimated that in the 1840s, at the height of Irish immigration, some 60 percent of the adult white male population in Rhode Island could not vote because they failed to meet the property requirement. Some sources place the percentage even higher.

Voting was not the only civil right denied to non-freemen. Under the charter and according to later interpretations by the General Assembly, only freemen could sit on juries or bring a suit before a court of law. A non-freeman could not sue a freeman for legal wrongdoing, unless he could find another freeman to sponsor him. The case would then be heard by a jury made up entirely of other freemen—so much for a jury of one's peers. The charter truly created a whole population of second-class citizens.

Critics of the charter also condemned the apportionment of representatives—the "deputies"—as originally laid down. While it may have been fair in 1663, it made no allowance for the growth of cities and towns.

Newport had been the colony's chief city, ranking with Boston, Philadelphia and New York in importance, and therefore the six deputies the charter called for had probably been warranted. But Newport never fully recovered from the ruinous British occupation during the Revolution, when most of the citizens had fled and the redcoats destroyed much of the city, tearing down houses for firewood. By 1840, Newport still sent six deputies (now called representatives) to the General Assembly, despite having a population of just over eight thousand. Providence, on the other hand, the state's largest city with a population of over twenty-three thousand, was only allowed four representatives under the rules of the royal charter. This disproportionate representation proved to be another serious bone of contention with the old charter system.

Lastly, the near limitless power of the General Assembly was questioned. While the charter established the office of governor, it nowhere described the governor's duties, rights and responsibilities. He was merely an officer of the General Assembly with no veto power, a figurehead enacting the assembly's will. The assembly also appointed judges to the courts, and of course only those sympathetic to or connected with the assemblymen got the job. With an essentially powerless governor and a puppet judiciary, the system of checks and balances as laid out in the United States Constitution was nowhere to be found, with two of the branches squarely in the hands—or pocket—of the third. One assemblyman was heard to remark, "Sir, I conceive that this body has the same power over the non-freeholders of this state that the Almighty has over the universe."

As the charter contained no provisions for its own amendment and therefore could not be changed, many simply advocated that it be replaced with a new constitution entirely. There were a half dozen calls for constitutional conventions issued over the years; only two of them actually resulted in a convention being held to write a new constitution. The convention of 1824 drafted a constitution that, when placed before the freemen, was voted down two to one, and the constitutional convention of 1834 accomplished nothing before adjourning in ennui.

Unsurprisingly, the freeman oligarchy rolled its collective eyes at talk of framing a constitution. Francis Wayland, president of Brown University, sneered:

> *Until very lately, it has been really doubtful whether a change was actually desired by any large number of our citizens. Petitions on this subject were, it is true, several times presented, but they never seemed to arise from any strong feeling, nor to assume a form that called for immediate action.*

The Charter

Wayland's attitude was benign compared to that of Representative Benjamin Hazard, who issued what is known as Hazard's Report to the State House of Representatives. Paying particular attention to the petitions advocating the expansion of suffrage, he wrote angrily and dismissively that his committee found "nothing…either in facts or of reasoning, which requires the attention of the house. If there is anything noticeable in them, it is the little sense of propriety manifested in the style in which they are drawn up." Reserving a special ire for immigrants, he declared, "Their ancestors were not among ours. Their natural connexions are in other places; and their habits, attachments, and predilections have been formed before they came." The report concluded shudderingly:

> *We ought to recollect that all the evils which may result from an extension of suffrage will be evils beyond our reach. We shall entail them upon our latest posterity without remedy. Open this door, and the whole frame and character of our institutions are changed forever.*

Many argued that extending suffrage would pave the way to rampant voter fraud. The logic is not very clear, and certainly fraud was unbridled anyway. For example, the powerful and wealthy Sprague family, owners of the Cranston Printworks, a mill company that employed thousands, often granted their male workers $134 of land via quitclaim deed and sent them out to vote as they were told. The deeds were then dutifully returned to the family the next day.

It should come as no surprise that the advocates and opponents of expanded suffrage were divided along social class, and therefore political party membership, but also geographical location.

The freemen, the majority of whom opposed expanded suffrage, were generally well-off old money families who had lived in Rhode Island for generations. Derisively characterized as "aristocrats" and "ruffled-shirt gentry," they were usually members of the Whig Party who lived in the more rural cities and towns in the southern part of the state. This is not to say that the suffragists had no supporters among the freemen; a group of freemen did in fact support the cause, but they were more the exceptions than the rule.

Advocates of extending voting rights were overwhelmingly urban Democrats in the industrialized northern half of the state. They were mostly millworkers, laborers, tradesmen, artisans and other blue-collar "mechanics," with a large percentage of first- and second-generation immigrants, most often Irish. Pro-suffrage speakers appeared before the crowds dressed in

The Dorr War

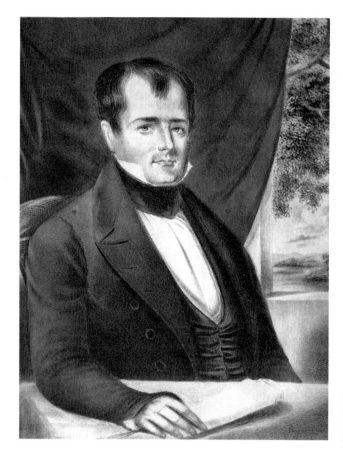

A somewhat idealized portrait of a young idealist. *Courtesy of Russ DeSimone.*

green baize jackets intended to underscore their working-class origins and distance themselves from the ruffled-shirt aristocrats.

One of the men vociferously demanding the expansion of voting rights was a young lawyer and state representative from Providence named Thomas Wilson Dorr.

2
WE THE PEOPLE

Nothing in Thomas Dorr's early history even hinted that he would become one of the most radical reformers in Rhode Island history. Born into a patrician family on Providence's east side on November 5, 1805, he was the oldest son of Sullivan Dorr, a wealthy manufacturer and conservative Whig; the Whig party had always been associated with the commercial and manufacturing class to which the family belonged. His mother was Lydia Allen, a member of another old-money family. The Dorrs lived in a large mansion on Benefit Street that still stands today. The apple orchard out back was a frequent target of the local boys, who often stole apples, as well as the site of Roger Williams's original grave. Williams's remains, consumed by the roots of a nearby apple tree, were exhumed and relocated many years later.

Young Tom was sent to Phillips Exeter Academy in New Hampshire and then enrolled in Harvard College, graduating with honors in mathematics in 1823. He studied law in New York under some of the leading jurists of the day and passed the Rhode Island bar in 1827. He specialized in maritime and commercial law, slowly building his practice. Some accounts paint him as more of a legal scholar than a courtroom lawyer.

Abraham Payne, a friend and political ally, would later remember Dorr this way:

> He was college bred, studied law, and in due time opened an office. He was rather lazy and had none of the tact which enables a man to adapt himself to circumstances, and, lacking this was wholly unfit to practice law among Yankees. They go to law to get their cases and nobody who have this object

in view would think of employing Mr. Dorr. He read very extensively, mostly upon political subjects, interested himself in every good cause, and was an estimable and much esteemed man…He was no politician and that was much to his credit…He could not lead and he would not follow. I by no means mean to disparage Mr. Dorr…I still think he was a very honest and able man. He was an abstractionist. In other words, he had clear convictions and he had faith in his convictions. He was a just man. He never misrepresented or traduced an opponent, and he never deserted a friend. He never concealed his opinions to gain personal ends, nor would he under any circumstances surrender principle to policy. He was a dull speaker and a prosy writer and only those with a deep interest in the subject and desired instruction could hear or read him through.

And that was from someone who liked him.

He entered the General Assembly in 1834, representing Providence's Fourth Ward as a Whig, at twenty-nine years of age. He must have disappointed his family when he left the party a few years later in 1837,

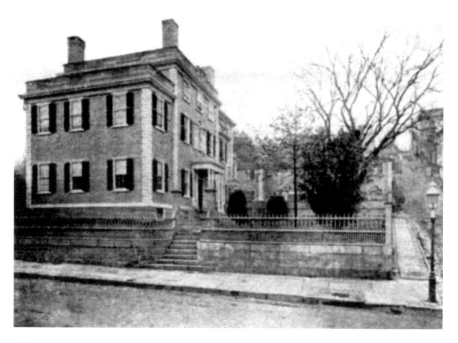

A late nineteenth-century photograph of the Dorr mansion. *Author's collection.*

a becoming liberal Democrat. He went about his duties with all the high-minded idealism that seemed to characterize the Dorrs.

As a representative, he worked for banking reform, the expansion of public education and the elimination of imprisonment for debt. In private life, the unmarried Dorr was a staunch abolitionist and advocate of the state's ancient principle of religious liberty. He was treasurer of the Rhode Island Historical Society, president of the Providence School Committee and a commissioner of the Scituate Bank. Between all of this and his law practice, he was a busy man.

In person, he cut anything but a heroic figure. He was short, portly and walked with a limp, one leg being slightly shorter than the other. He apparently had a fondness for cigars.

He quickly threw himself into the suffrage cause.

The year 1840 saw several events that would later prove important in the history of suffrage in Rhode Island.

First was the election of Johnston's Samuel Ward King as governor. The fifty-four-year-old King had entered the General Assembly in 1838, and when infighting among the Whigs resulted in no candidate being elected, he served as acting governor in 1839. A vocal opponent of the expansion of voting rights, he won the race for governor the following year. Before entering politics, he was a physician who studied at Brown University and served as a surgeon aboard a privateer during the War of 1812. He was the father of fourteen children, only half of whom survived into adulthood.

Agitation for the framing of a new constitution and expansion of suffrage simmered throughout the year, leading to the formation of the Rhode Island Suffrage Association that fall. While largely drawing its support from the mechanics and tradesmen, a number of freemen also supported the association's goals, notably Dorr himself, and Representative Samuel Y. Atwell, Dorr's friend and ally in the General Assembly. Soon, branches of the association were flourishing in cities and towns throughout the state.

On November 20, the first issue of the *New Age*, the association's newspaper, rolled off the presses. Remaining dedicated to the suffrage cause, the weekly *New Age* and its sister paper, the *Daily Express*, avoided official alliances with Whig or Democrat partisans and kept the focus on suffrage.

The association's grassroots efforts and growing numbers had the desired effect. In its January 1841 session, the General Assembly, bowing to public pressure, called for a convention to be held the following November to draft a new state constitution. Whatever relief the association must have felt at this

THE DORR WAR

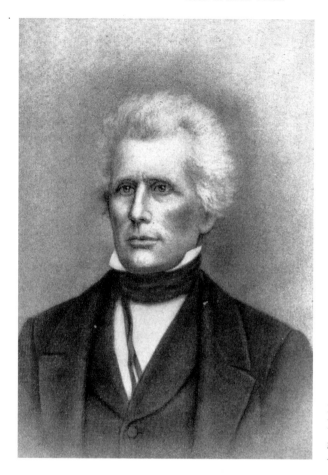

Samuel Ward King, Dorr's opponent for the Rhode Island governorship. *Courtesy of Larry De Petrillo.*

announcement quickly evaporated when it realized that only freemen would be allowed to select delegates to the convention and that those delegates were specifically instructed to work on revising and modernizing the representation of cities and towns in the General Assembly. The question of expanded suffrage was completely ignored, and the association's ultimate goal would clearly not be realized.

In February, realizing it could expect nothing from the proposed convention, the no-doubt angry suffrage association issued a declaration of principles, succinctly stating the arguments that many had made for decades:

> *Believing that all men were created equal, and that possession of property should create no political advantages for its holder, and believing that all bodies politic should have for their foundation a bill of rights, and a written*

constitution, wherein the rights of the people should be defined, and the duties of the people's servants strictly pointed out, and limited; and believing that the state of Rhode Island is possessed of neither of those instruments, and that the charter under which she has had her political existence is not only aristocratic in its tendency, but that it lost all its authority when the independence of the United States was declared; and furthermore believing that every state in the federal compact is entitled by the terms of that compact to a republican form of government, and that any form of government is anti-republican which precludes a majority of the people from participating in its affairs; and that by every right, human and divine, the majority of the state should govern; and furthermore, and finally, believing that the time has gone by when we are called upon to submit to the most unjust outrages upon our political and social rights, therefore,

RESOLVED: That the power of the state should be vested in the hands of the people, and that the people have a right, from time to time, to assemble, whether by themselves, or their representatives, for the establishment of a republican form of government;

RESOLVED: That whenever a majority of citizens of this State, who are recognized as citizens of the United States, shall, by their delegates in convention assembled, draft a constitution, and the same shall be accepted by their constituents, it will then be, to all intents and purposes, the law of the State.

The association took other steps as well, organizing a mass meeting in Providence on April 12, 1841, in favor of expanding voting rights. The *New Age* enthusiastically announced the meeting, and the *Republican Herald*, a Democratic newspaper sympathetic to the suffrage cause, expressed a hope that the gathering would be a "precursor of a signal success, equal to the importance and justice of the object."

The chilly rain that fell that day did nothing to dampen the spirits of the two to three thousand who showed up. Church bells rang throughout the city, despite some outraged freemen of the First Congregational Church trying to wrestle the bell rope from their sexton. A battalion of butchers in long white aprons led a parade, carrying aloft a banner depicting an ox declaring "I Die For Liberty." Behind the butchers came some two dozen elderly veterans of the Revolution in carriages, flying a banner asking, "We Fought for Freedom: Shall We Die Without Our Freedom?" Bands played a new tune, "The Suffrage Quickstep," composed for the occasion, and many marchers carried banners and standards reading, "Worth Makes the Man,

The Dorr War

A broadside announcing a major suffrage rally; the ox probably could have done without the "punctual attendance" of the two to three thousand said to have shown up. *Courtesy of Brown University.*

but Sand and Gravel Make the Voter," "Virtue, Patriotism, and Intelligence vs. $134 Worth of Dirt," "The People Will Have Their Rights" and, most ominously, "Peacefully If We Can, Forcibly If We Must." Still others wore ribbons simply reading, "I am an American Citizen," indicating that they expected all the rights due to them as such.

The parade made its way through the streets of Providence before gathering on Jefferson Plain, the site of the modern-day Rhode Island Statehouse; in a strangely portentous coincidence, Jefferson Plain was directly across from the state prison. Gathered together, they heard speeches, sang the 100th Psalm ("Make a joyful noise unto the Lord…") and partook of a "magnificent collation" consisting of an ox, a calf and a hog roasted by

the butchers, a loaf of bread ten feet long and two feet wide prepared by a team of bakers, and "several barrels of beer." Thus fortified, a portion of the marchers then retired to the town house—nearby on Benefit Street—for a business meeting to discuss further plans.

This was the first of several pro-suffrage mass meetings held throughout the spring and into the summer of 1841. Speeches were made, resolutions were passed, beer was quaffed. It was decided that if the General Assembly would not accede to the people's wishes, then the people must take matters into their own hands.

"If the sovereignty doesn't reside in the people, then where in the hell does it reside?" became their oft-asked question. Those ruffled aristocrats, in turn, grumbled that the uneducated rabble could not even pronounce the word "sovereignty" correctly, mangling it into something like "sover-IN-ty."

Accordingly, the suffrage party issued a call for all adult males over the age of twenty-one—regardless of property ownership—to vote on delegates for their own constitutional convention to be held at the town house on Benefit Street. If the General Assembly could not be trusted, the people would handle things themselves.

In these early days of the movement, black voters were at least in theory welcome to vote for convention delegates. Rhode Island's black citizens had had the vote for many years, but the General Assembly disenfranchised them in 1822. Hoping that a more liberal constitution

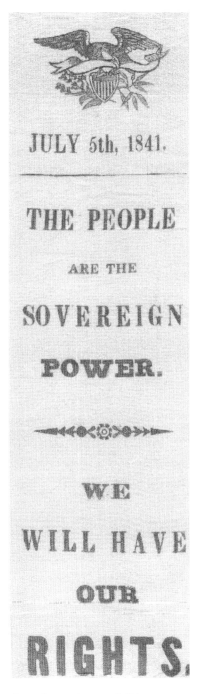

One of several types of ribbon worn at the various suffrage rallies. *Courtesy of Russ DeSimone.*

would restore their voting rights, many black men went to cast their vote for delegates to the convention. Unfortunately, in some areas of Providence, they were turned away from the polls when they arrived.

Delegates were chosen in August, and the People's Convention was scheduled for October, a month before the convention called by the General Assembly.

Committees, the inevitable byproduct of democracy, were organized for the People's Convention. The one that attracted the most scrutiny from advocates and opponents alike was the committee on "Electors, the right of suffrage, and elections," chaired by Thomas Dorr.

3
THE PEOPLE'S CONSTITUTION

What came to be known as the People's Convention met on Monday, October 4, 1841, amid little fanfare. The suffragists intent on framing their own constitution attracted little attention, simply because almost nobody else took them seriously. The delegates set to work creating a new basic law for the state, and by the end of that week, they had accomplished their goal.

The constitution they produced was a fairly liberal document that sought to remedy both the excesses and the shortcomings of the charter. It included a bill of rights, a separation of powers into executive, legislative and judicial branches and a secret ballot clause—a new idea for Rhode Island, which had had open ballots up until that time. The framers chose to deny certain public offices to non-taxed citizens (this was in the old days before universal taxation) and required those voting on matters of municipal finance to have resided in the town in question for six months and own $150 in real estate (while this might be seen as being in conflict with the declaration of principles issued by the suffrage association, it seems to have passed without comment).

The people's constitution reapportioned and balanced representation in the General Assembly, even though it repeated the charter's mistake of fixing the number of representatives town by town, not taking into account population or the growth or decline thereof. So Newport, for example, lost one representative and was now allowed five. Portsmouth, previously sending four representatives to the General Assembly, now sent only two. Providence, then divided into six wards, was allowed one representative per ward.

The Dorr War

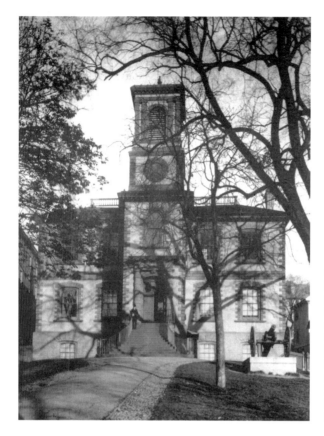

An atmospheric, early twentieth-century photograph of the old statehouse, called the town house, which was the site of the People's Constitutional Convention in 1841. Dorr and his legislature would later find themselves locked out of the building. *Courtesy of Larry De Petrillo.*

Of course, the most radical revisions appeared in the article that Dorr's committee had drafted, the first section of which read:

> *Every white male citizen of the United States, of the age of twenty-one years, who has resided in this state for one year, and in any town, city, or district of the same for six months preceding the election at which he offers to vote, shall be an elector of all officers.*

The people's constitution thus abolished the age-old property requirement that had barred so many from voting.

There was, however, some controversy over the details. The idealistic Dorr, who had clearly embraced the cause of universal male suffrage, advocated taking it to what he must have seen as the logical conclusion by granting the vote to the state's black population. This caused strenuous debate in committee.

The People's Constitution

There was, of course, no discussion of extending suffrage to women. That idea had been tabled years before, despite many women being very active and vocal as advocates and organizers in the suffrage cause. Indeed, the feisty Ann Parlin served as the no-nonsense secretary of the Rhode Island Suffrage Association for quite some time. The denial of extending suffrage to women was justified as being based "upon a just consideration of the best good of society including that of the sex itself."

In 1841, seeking to give blacks the vote made one a visionary. Seeking to give the vote to women made one a lunatic and doomed him to failure.

In the draft of the proposed constitution presented to the people for approval, the phrase "every white male citizen" remained. Dorr, sticking to his principled guns, made sure to insert a clause at the end of the document, reading: "The general assembly shall, at their first session after the adoption of this constitution, propose to the electors the question, whether the word 'white'…shall be stricken out."

While many on the suffrage party were more pragmatic, Dorr remained idealistic and was prepared to argue the point with his own people.

The landholder's convention—or the freemen's convention, as it is sometimes called—convened on Monday, November 1, 1841. Members of this convention were already familiar with the text of the people's constitution; that document had already been circulated far and wide, and even the critical *Providence Daily Journal* published it on the front page. This was unusual for the time, when the front page was generally given over to advertisements or, occasionally, political or even religious screeds reprinted from other sources. Actual news was on page two, and page three often featured a mix of ads, poetry, humor, fiction and short man-bites-dog news items. Sometimes this spilled over onto the back page, with the rest of the space being taken up once again with advertisements. The people's constitution made front-page news in a time when there was almost no such thing as front-page news.

The constitution drawn up by the freemen showed a marked similarity to the people's constitution. It likewise included a bill of rights and defined the three branches of government, among other measures.

But there were, of course, certain noticeable differences.

The freemen's constitution adjusted representation in the General Assembly more thoroughly and more fairly than had the people's constitution. Both the charter and the people's constitution had assigned the number of representatives to each town specifically, by name. The freemen

now apportioned representation according to population, allowing for no fewer than two representatives per town and no more than eight.

Article 2 of the proposed constitution offered voting rights to "every white male native citizen of the United States," removing the ancient requirement of freeman status. It also gave the vote to naturalized immigrants who had resided in the state for at least three years after naturalization—actually lengthened from the previous residency requirement of one year.

However, the freemen still stubbornly refused to budge on the property requirement. The right to vote still hinged on that magical $134.

The People's Convention reconvened and made a few revisions to its constitution. The convention considered a lengthy and eloquent petition submitted by the "Colored Citizens of Rhode Island."

> *To the Free Suffrage Convention. Gentlemen, the remonstrance of the undersigned colored citizens of Rhode Island respectfully represents that in the constitution that is proposed to be sent forth by your respected body for adoption, there is one measure inserted, upon which we, as an interested party, beg leave, with deference, to make known our views, and give an expression of our sentiments. We have reference to that article which, in inserting the word "white," denies all persons of color the use and exercise of the elective franchise.*
>
> *Against the sacrifice of an ill-used and unoffending people, we desire to enter our most solemn and earnest protest. We are unwilling that this sore, grievous, and unwarrantable infliction should be made upon our already bruised hearts, without lifting up our voice in clear, strong, and decided remonstrance.*

Damning the proposed constitution as "anti-republican"—a description that must have stung—the impassioned plea went on:

> *We know of no authoritative standard where the right of man to participate in the privileges of government is predicated of their personal appearance or bodily peculiarities. We know of no system of political ethics in which rights are based upon the complexion of the skin.*

The idealistic Dorr, who no doubt agreed with the petition, once again clashed with the more realpolitik members of the convention. Several prominent abolitionist leaders, among them Frederick Douglass, even visited Providence to speak out in support of the petition. But attempting to extend

FRIENDS OF THE Constitution! TO THE POLLS!

TWO DAYS YET REMAIN FOR ACTION. IMPROVE THEM WITH A GOOD WILL, AND THE DAY IS OUR OWN. Yesterday, the enemy mustered in force, from all their strong holds, and poured in like a flood, Yet, after all, the result of voting, gave our enemies about ELEVEN HUNDRED MAJORITY; and their calculation last evening, was, to count up at least THIRTY-FIVE HUNDRED! Thus, we have cut them down TWENTY-FOUR HUNDRED at least, below their calculation; and which is ONE THOUSAND better than we had anticipated. ONE MORE RALLY TO-DAY, AND ONE MORE TO-MORROW, AND SUCCESS WILL CROWN OUR EFFORTS. GO IT MY HEARTIES; and let not a LEGAL VOTER on OUR SIDE, be missing from the polls. Turn a deaf ear to all idle rumors, and stop not to calculate the result; but SWELL OUR NUMBERS TO THE UTMOST.

FRIENDS OF SUFFRAGE!

BE NOT DECEIVED! Take from the number of votes already cast *against our Constitution*, those cast by men in *favor* of the CHARTER, and consequently AGAINST the "PEOPLE'S CONSTITUTION," and it will be found that there is already a MAJORITY OF MORE THAN ONE THOUSAND at the polls, AGAINST THAT CONSTITUTION. That MAJORITY WILL BE INCREASED; and *that Constitution cannot be carried into effect,* even if nothing but a majority of the votes were necessary. YOUR ONLY CHANCE TO SECURE AN EXTENSION of SUFFRAGE, is to vote NOW FOR THE CONSTITUTION. If you have voted against it, embrace the opportunity while you may, and CHANGE YOUR VOTES. *Place no reliance on the People's Constitution.* It is but an airy castle. If the legal Constitution should be rejected, the OLD CHARTER WILL STAND, AND BE SUSTAINED. Remember that, and complain not if by YOUR OWN VOTES, YOU PREVENT AN EXTENSION OF SUFERAGE.

A broadside urging voters to support the charter and "Place no reliance on the People's Constitution. It is but an airy castle." *Courtesy of Brown University.*

the vote to blacks would create serious obstacles, if not outright barriers, and in the end, no changes were made on the question of black suffrage.

The people's proposed constitution was approved by the convention and sent forth to the adult white male voters for a three-day referendum beginning on December 27, 1841. Over the course of those three days, it

A ballot voting in favor of adopting the people's constitution. The voter would sign his name on the back to cast his vote. *Courtesy Russ DeSimone.*

received 13,944 votes in favor of its adoption. As the pro-charter freemen refused to take part in what they saw as an illegal referendum staged by a band of outlaws, the constitution received a scant 52 votes against it.

It was estimated that there were some 23,142 adult white males who, under the people's constitution, were eligible to vote, and therefore the 13,944 votes showed that the majority of voters approved the new constitution. Furthermore, 4,960 of the state's estimated 9,950 freemen had voted in favor of the people's constitution.

The People's Convention and the suffrage party had been derided as a "tempest in a teapot" by their critics. Now the *New Age* proudly published the tabulated votes along with a cartoon of a teapot boiling over. The people and the suffrage cause had triumphed overwhelmingly.

Article 14, Section 17 of the people's constitution reads:

> *The present government shall exercise all the powers with which it is now clothed, until the said first Tuesday in May, one thousand eight hundred and forty-two, and until their successors, under this constitution, shall be duly elected and qualified.*

Having won the adoption of their constitution, leaders of the suffrage cause now politely waited for the current freemen's government to step down in just a few short months.

It was a fatal mistake.

4

A MOVEMENT AGAINST ALL LAW

Thomas Dorr was a man who placed the utmost faith in the people. As far as he was concerned, the people had spoken, and the new constitution was now law. He and the other suffrage leaders seemed to expect the King administration to simply hand over the reins of government on the first Tuesday in May, but they were sorely mistaken. While they were slapping one another on the back at their victory and readying for their April elections, Governor King and his people, now realizing they had a serious problem on their hands, prepared their counterattack.

King appealed to federal district court judge John Pitman, who lost no time in condemning the People's Convention as criminal and revolutionary. Justice Job Durfee, addressing a grand jury then empanelled as part of the usual court business, delivered a lengthy charge that, at times, bordered on an angry rant. In his widely published charge, he crystallized the main arguments raised against the People's Convention and its constitution:

> *I therefore say to you, that, in the opinion of this court, such a movement…is a movement which can find no justification in law; that if it be a movement against no law in particular, it is, nevertheless, a movement against all law; that it is not a mere movement for a change of rulers, or for a legal reform in government, but a movement which, if carried to its consequences, will terminate the existence of the state itself.*

Raising the specter of bloody anarchy by comparing the suffragists to the mobs of the French Revolution, Durfee insisted that the people at large had

THE DORR WAR

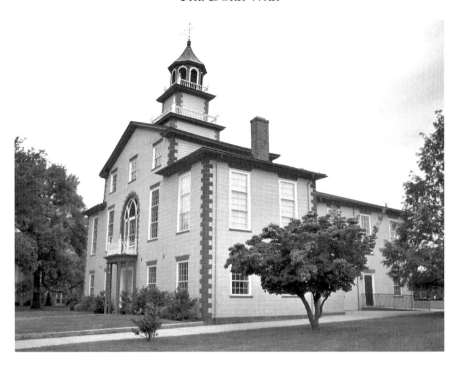

The Bristol County Courthouse where Job Durfee delivered his infamous charge to the grand jury, condemning the people's constitution as treasonous and without law. The building dates to 1816 and was designed by Russell Warren, who also designed the Arcade in downtown Providence. *Photo by Robert O'Brien.*

no power to make the decisions they had arrogantly proceeded to make. Sovereignty did not reside with the people but only with the body politic. Abiding by the rule of the charter, "none but a corporate people has the capacity to receive and exercise sovereignty." The corporate people and the body politic were, of course, the freemen. Thus, "this pretended constitution" framed by the People's Convention and adopted by overwhelming popular vote "is without legal authority, and of no more value in the courts of the Union than so much blank paper."

Declaring that every citizen owes the state his allegiance, Durfee summed up:

> *I therefore say to you, and others duly qualified, that it will be lawful for you to vote on the constitution now submitted to you by the state convention, and if it be adopted, any person in this state commits a breach of allegiance who willfully fails to support it. If it be not adopted, it will be our duty still to adhere to that compact of our ancestors called the Charter, as that*

> sheet anchor at which our beloved State has triumphantly ridden out many a storm, and can as triumphantly ride out this. And as to that instrument called "The People's Constitution," however perfect it may be in itself, and however strong may be the expression of public opinion in its favor—yet, standing as it does, alone and without any legal authority to support it, it is not the supreme law of this state; and those who may attempt to carry it into effect by force of arms, will, in the opinion of this court, commit treason—treason against the State—treason perhaps against the United States—for it will be an attempt by the overt act of levying war, to subvert a State which is an integral part of the Union, and to levy war against one state, to that end, we are all apprehensive will amount to levying war against all.

As only freemen were allowed to sit on juries, Durfee's jeremiad was delivered to a sympathetic audience. He was preaching to the choir.

Now that the judges had entered the fray, Dorr fired back with his own distillation of the suffragists' position, entitled "The Right of the People to Form a Constitution: The Nine Lawyers' Opinion." Dorr drafted the document; the other eight, including Samuel Y. Atwell, read it over and signed it.

Dorr and his colleagues argued that after independence was won, sovereignty passed to the whole people, not just those with $134 in property. The people had petitioned the General Assembly for a new constitution, and when the General Assembly had refused to comply, the people were more than justified in taking matters into their own hands. Dorr differed sharply with Durfee, insisting that the government was the servant of the people and not the other way around.

That, in many ways, was the fundamental question of the Dorr War.

Dorr put his first-rate legal education to good use, marshaling quotes from over a dozen authorities to add weight to the suffrage cause, concluding:

> We respectfully submit to you, fellow citizens, that the People's Constitution is "a republican form of government" as required by the Constitution of the United States, and that the people of this State, in forming and voting for the same, proceeded without defect of law, and without violation of any law.

Battle lines were drawn and the war for public opinion was joined. As many of Dorr's supporters were landless Irish immigrants, the freemen did not hesitate to use nativist fear-mongering to sway the public. Nativism has a long and unfortunate history in the United States, as native-born

Americans (often styling themselves as "Patriots") who have forgotten their own immigrant ancestry speak out against new foreign arrivals. While the immigrant groups have changed over the centuries, the rhetoric has not. Benjamin Franklin condemned German immigrants with the same talking points still used today against others, stating that Germans "will soon so out number us, that all the advantages we have will not, in my opinion, be able to preserve our language, and even our Government will become precarious." Elsewhere, he railed, "Why should Pennsylvania, founded by the English, become a Colony of Aliens, who will shortly be so numerous as to Germanize us instead of our Anglifying them, and will never adopt our Language or Customs."

In an era when "foreigner" was largely synonymous with "Irish," many whispered of dark Catholic plots, and Help Wanted ads included the phrase, "No Irish Need Apply." In New York City, St. Patrick's Old Cathedral was surrounded by a high wall (built overnight, according to legend) to protect parishioners after Nativist rioters attacked the building and shattered the stained-glass windows on a dark night in 1842. Unfortunately, such episodes were common during the period.

The native Yankees reacted to foreigners with a kind of horror they yet relished. One typical broadside circulating in March 1842, just as the freemen's constitution was placed before the voters, warned that adopting the people's constitution

> *will place your government, your civil and political institutions your PUBLIC SCHOOLS, and perhaps your RELIGIOUS PRIVILEGES under the control of the POPE OF ROME, through the medium of thousands of NATURALIZED FOREIGN CATHOLICS.*

The broadside included a description of a meeting in New York City, where "a band of foreigners broke in upon the assemblage, and by means of violence broke up the meeting" of citizens gathered to discuss the question of foreign voters. The "peaceful body of American citizens" was set upon by

> *bands of filthy wretches…drunken loafers; scoundrels who the police and criminal courts would be ashamed to receive in their walls, coarse blustering rowdies; blear eyed and bloated offscourings from the stews, blind alleys, and rear lanes; disgusting objects bearing the form human, but who the sow in the mire might almost object to as companions.*

A Movement Against All Law

FOREIGN VOTERS!!

Fellow-Citizens:

You are threatened by the Dorr-Jackson party with the abolition of the freehold qualification for *Foreign Voters*. The success of this party would open the way to other great evils, but I now invite your attention mainly to this, the greatest which could befal the State.

The situation of Rhode Island in having comparatively a small agricultural population differs from that of the other States. The bulk of our people are engaged in other pursuits. Our territory is small, and our immense capital is invested in trade, in the mechanical arts, and in manufactures. This has created in Rhode Island an immense demand for *foreign labor*, especially in the city of Providence, and the surrounding villages.

The city alone contains many thousands of this class of inhabitants, and the cry is still the; come.— Already it has two large catholic chapels exclusively for Irishmen, and they are in want of a third. Moreover, every valley in the north part of the State through which flows any portion of our vast water power, is overflowed with a foreign population, still unreclaimed from the ignorance and superstitions of the Old World.

Now it is this great preponderance in Rhode Island of the interests of trade, the mechanic arts and manufactures supported by foreign laborers, *over* the interests of agriculture, which constitutes our danger. No other State in the Union is, in this respect, so fearfully situated. In no other State are the Farmers in such danger of being overwhelmed by classes connected with other interests. Massachusetts has single counties larger than all Rhode Island, which are wholly agricultural. New York, notwithstanding her vast commerce, her arts, and her immense traffic, is still an empire of Farmers.—So of Pennsylvania, and of other States. The influence of foreign voters is little felt in these States, except where they abound in the large and populous cities. In State elections their influence is neutralized by the immensely greater vote of the Farmers. But this could not be in the State elections of Rhode Island, because the vote of the Farmers instead of being greater is FAR LESS.

Take a view of this subject through the unerring medium of figures. Providence County has a population of 70,000, being about seven-twelfths of the entire people of the State. Of this number the city and the factory villages constitute above 50,000.— Add to these the people of Warren, Bristol and Newport, and those of the factory villages in Kent, and you will have left in the whole State for agricultural inhabitants, only a fraction of the people.

Again in ten years Providence alone will embrace one-half of the people of Rhode Island. Already she has 5000 voters, and but for the freehold qualification for foreigners, she would have nearly 7000.

The citizens of Providence do not desire this preponderance of political influence. They know it would be safer for them, and for all concerned, to share the power of the State more equally with the agricultural towns. The Farmers are conservative; they are attached to existing institutions, and unfriendly to hasty innovations. In their hands power is always safe. The people of Providence look to the agricultural towns for their preservation from radicalism. Once already they have been saved by the *Farmers*, and they feel deeply grateful for it. They will never forget the march of the Farmers to their rescue in 1842; and they now implore the same patriotic Farmers to save not only Providence but the whole State from a greater evil even than civil war—AN OVERWHELMING FLOOD OF FOREIGN VOTERS.

Fellow-Citizens, I pray you to consider the evils to free government which must result from abolishing the freehold qualification for foreigners. I have pointed out to you the preponderance of laborers and artizans of foreign extraction in Providence and the surrounding villages. I have shown you that this preponderance must go on increasing every successive year. Let me now mention to you that this class of voters always vote together. The individual exceptions are too few to be taken into account. The Irish Catholic voters uniformly vote one ticket, and they vote it in a body. It is no matter what the secret influence is, or whence it comes, which thus binds them together. It is enough to know that such an influence exists, and that it never fails of effect. You may say that it is the result of ignorance, or that it is owing to the Catholic Priests, or you may refer it to some other cause; the fact still remains, that this class of voters are uniformly governed by some secret influence not known to the rest of the people. It is this that makes them dangerous to our institutions. I say it disqualifies them from participating in the elective franchise upon the same free terms with the native inhabitants.

If, then, you abolish the qualification which has wisely been prescribed for them, you will give the City of Providence, where this class abounds, forever into their hands. Providence will ever after vote one way. But as the preponderance of voters in Providence nearly balances the State, to give Providence to the foreign voters will be to give the State to foreign voters. To do this will be to give Rhode-Island, in all her politics, State and Federal, over forever to the worst and lowest forms of Locofocoism. Nine-tenths of the foreign voters throughout the country uniformly vote the ultra-radical ticket in all elections. They always vote against the conservative party. Every Roman Catholic Irishman in Rhode-Island is a Dorrite, and you may his cap at the name of James K. Polk. It is a stupendous fact that foreign votes defeated the election of Henry Clay, and gave to the people of the United States their present national administration. Foreign votes have uniformly of late years determined all the elections in the city of New-York, and a *foreign Catholic Prelate* has on all such occasions presided at the mysteries. Give, then, to this class of your citizens the same means of abusing the elective franchise in Rhode-Island, and you will bow her native-born people to the will of foreigners forever!— Would this be wise, expedient, or just? Ought the adopted citizen to ask it? If conceded, would he use it as a blessing and a boon, or from not imbibing the true spirit of our institutions, might he not rather abuse it as a curse and a wrong? Are the native people, who dwell amidst the monuments and tombs of their fathers, prepared for such a bondage? Are they prepared to give up the heritage of their fathers, here in the land of Roger Williams, *to men who come and go with the seasons?* Will they cast away birthrights which they prize so dearly, to be perverted by men, the greater part of whom have no common permanent interests or lasting attachments in the community, which they would assume to govern?

People of Rhode-Island, if you would defend the institutions transmitted to you from the times of Roger Williams, you must do it at this present election. If you would not be governed by the alien and the foreign-born, you must avoid the yoke before you feel it upon you. If these *foreign Papists* once get the power, they will never yield it back to you.

Remember that the want of a single vote on election day may determine the fate of Rhode-Island for many generations. Rely upon it, that this *allied*, this *Dorr-Jackson* party are *pledged* to the abolition of the freehold qualification for foreign voters;— *pledged* to the abrogation of the most essential safeguard to freedom and good government in our Constitution.

The fact that this pledge has been given is established by many explicit and ample proofs. Let the following suffice:

About the first of this present March, two of the Providence *Newspaper* organs of Gov. Jackson issued calls for a meeting of Foreigners, which was held on the fifth instant in Providence, and addressed both by foreign and native born orators. The meeting adopted the following resolutions:

Resolved, That as native and adopted citizens were of equal importance in effecting the independence of these United States, and in elevating this nation to its present greatness and prosperity—they are equally entitled to political and civil rights, and every attempt to deprive any portion of American citizens of their voice in the government of the country, is an advance towards the political bondage of the whole people, and ought to be rebuked on the ground of self defence by every citizen who claims the protection of the laws of his country.

Resolved, That this association has been organized for the specific object of obtaining an equality of political rights for adopted citizens, and as our object is specific, our course should be independent.

Tee speeches made on the occasion were in harmony with the resolutions. One of the speakers said that *"Foreigners had rights*—the right to vote —*which they did not ask for, but demanded. If war or danger approached, he would advise them to tell their oppressors that they had no soil. You have robbed us of our rights. defend your soil with your own blood; we have nothing to fight for."* This was tall talking for the allies and friends of the "true Whigs." Another of the speakers said, *"One more effort must be made to reform the errors in the constitution,* (freehold qualification for foreigners,) *and with union and perseverance, the Irishmen would succeed.— The gentlemen on the ticket recommended by the Democratic Convention, if successful would use all their personal and official influence to correct the evils which the naturalized citizens have so patiently borne.— They had said so, and if they were honorable men, they would do so."*

Now these resolves and speeches of the friends of Gov. Jackson have been published in the papers of all parties for more than two weeks, and circulated in hand-bills every where through the State. They impute to him an express pledge to use his influence to let in the foreigners without the freehold qualification. It is not known that he has on any occasion repudiated what his friends thus impute to him.

It is not known, that either he or any one on the ticket with him, has done so. Therefore, unless Gov. Jackson calls his friends to account, and repudiates these declarations, the public will have a right to suppose that thy spoke his mind, and with his knowledge and consent. The declaration, "they had said so, and if they were honorable men, they would do so," is too important for any candidate to permit to go forth to the public uncorrected, if it be false. But these candidates have permitted it to go forth without contradiction, and it is therefore true, and made on good authority. The true Whigs then have given pledges to the Dorrites in order to buy their votes.

But when was it ever before known that Whigs bargained with the enemy?

Why *do* Whigs bargain with men to whom they are equally opposed in State and in National politics?

Why do the Dorrites bargain with the Whigs?— Are they bought, and if they are,—as it is not money that has bought them, have Jackson and Simmons got their votes by selling parts of the Constitution of the State, and the freedom and liberties of the native-born inhabitants of the Land of Roger Wiliams?

ONE OF THE PEOPLE.

One of many nativist broadsides warning against the evils of extending suffrage to foreigners, full of sky-is-falling hyperbole. *Courtesy of Brown University.*

The Dorr War

Irish priests, "sly deceitful villains," encouraged the mob. The broadside concluded:

> *Rhode Islanders—read this. Ponder seriously on it. Say—are you prepared to witness such scenes enacted in your little and hitherto peaceful and prosperous state? Are you prepared to see a Catholic bishop, at the head of a posse of Catholic priests, and a band of their servile dependents, take the field to subvert your institutions…if not, vote for the constitution now presented to you, which is well calculated to protect you from such abuses.*

NATIVE AMERICAN CITIZENS!
READ AND TAKE WARNING!

A SHORT SERMON.

Let every soul be subject to the higher powers. *Romans*, 13, 1.

Christians, like all other men, have the right to protect themselves against oppression. They have also the right to aid in the protection of others, but our Savior said, "My kingdom is not of this world," and thus taught his followers that it was inconsistent with their duty to him, and with their respect for his doctrines, to mingle in the strife for power. Paul, in the above quoted text, did not intend to teach his brethren that they should submit, with degrading servility, to tyranny, cruelty, and oppression, when they could remove the evil without producing another equally great. But his frequent exhortations, as well as those of his DIVINE MASTER, fully show that they considered it the indispensable duty of CHRISTIANS to submit to existing governments for the sake of peace, until oppression became too cruel to be borne, or until the evil could be remedied without unnecessary violence; and that, in all cases, for the HONOR of the CHURCH, the SUCCESS of the GOSPEL, and the PEACE of the COMMUNITY, CHRISTIANS should "be subject to the HIGHER POWERS," as *long as forbearance would be a virtue*.

CHRISTIAN PROFESSORS OF RHODE ISLAND, I put to you a plain question—Will you answer it as on the altar of GOD, to HIM and your own consciences? Does it appear that the Constitution to be voted on for adoption or rejection, on the 21st, 22d, and 23d, inst. is of such a character as to threaten danger to your rights and privileges, or those of others? Is it oppressive in its provisions or bearings? Would you be justified in rejecting it, and in adopting another which will place your government, your civil and political institutions, your PUBLIC SCHOOLS, and perhaps your RELIGIOUS PRIVILEGES, under the control of the POPE of ROME, through the medium of thousands of NATURALIZED FOREIGN CATHOLICS? Does the honor and prosperity of the church require it? Do the peace, welfare, and prosperity, of the State require it? Yet, reject the Constitution now presented to you, and you show your preference for another, which, should *it ever be adopted*, WILL PLACE THE BALLANCE OF POWER IN THE STATE, IN THE HANDS OF THOSE PEOPLE. The event can readily be predicted. Would you defend yourselves and your church against the operations and predominance of such a power, and preserve the State from anarchy and ruin? Would you preserve peace, and thereby avoid violence and bloodshed? Would you pay that respect to the CONSTITUTED AUTHORITIES WHICH THE GOSPEL DEMANDS? Would you keep a conscience pure and undefiled, by pursuing a course on which you can hereafter look with approbation, and for the correctness of which, you can CONFIDENTLY APPEAL TO HEAVEN IN THE HOUR OF DEATH, AND AT THE DREAD TRIBUNAL HEREAFTER? Then, and I must suppose such to be your wish, array yourselves on the side of the "HIGHER POWERS," in a quiet and peaceable manner, GIVE YOUR VOTES FOR THE CONSTITUTION ON MONDAY NEXT. Show those who act in the opposition only to carry out their will, that you value too highly your christian profession, your christian character, and your christian principle, to countenance sedition, and to endanger the peace of an entire community, only to defeat the benevolent object of the existing government, and to give encouragement and support to a spirit of violence and disorder. Tell those who would allure you to aid them in the work of strife. 'WE HAVE NOT SO LEARNED CHRIST.'

REV. WILLIAM S. BALCH.

The above gentleman, late Pastor of the First Universalist Church in this city, and who, while here, did much for the party which have made and voted for the "*People's Constitution*," was requested by that party to lecture during his visit here this week from New York. He very properly refused to do so; and said he *would not were he now a resident here*; for the reason, that the party have carried the thing too far, and are now making *a political affair of it, and he would have nothing to do with it*. This is valuable testimony from one of the *ablest and fastest friends of the* suffrage cause.

AN EXAMPLE.

In a "Short Sermon" published in our extra sheet, the writer alluded to the possibility that, should a constitution like that called the "People's Constitution" be adopted, the naturalized foreign Chatholics might exercise a pernicious influence on our political, civil, and religious institutions, and on our public schools. We have a case in point. The CATHOLIC BISHOP HUGHES, of New York, at the last election in that city, arrayed under his control, some THREE THOUSAND foreign Catholic voters, after an effort of a few days, to sustain at the ballot box his own views on the question of public schools, for the purpose of diverting to the use of the CATHOLIC CHURCH, a portion of the common school fund of the State. With a longer period for the purpose, it is probable a body of foreign naturalized Catholics might have been organized, and will hereafter be organized, in that city and State, under papal ecclesiastical influence, *to carry out their views*. The excitement on the question still continues. The Bishop and his party are determined to succeed in their efforts. The native citizens have become alarmed. And meetings have been held to prevent the abhorred attempt from becoming successful.

On Wednesday last, a meeting was held in the Park, New York city, on the question. And during the proceedings, a band of foreigners broke in upon the assemblage, and by means of violence, broke up the meeting. A New York paper says, "Our cheeks are suffused with shame and indignation as we write about this matter; for so gross an insult to our rights as Americans, we have never seen or heard of before. Bands of filthy wretches, whose every touch was offensive to a decent man, drunken loafers; scoundrels who the police and criminal courts would be ashamed to receive in their walls; coarse, blustering rowdies; blear eyed and bloated offscourings from the stews, blind alleys and rear lanes; disgusting objects bearing the form human, but whom the sow in the mire might almost object to as companions—these were they who broke into the midst of a peaceful body of American citizens—struck and insulted the chosen officers of the assemblage, and with shrieks, loud blasphemy, and howling in their hideous native tongue, prevented the continuance of the customary routine. We saw Irish priests there—sly, false, deceitful villains—looking on and evidently encouraging the gang who created the tumult. We noticed two or three tavern bullies strike on the head a presiding officer—one of the most aged and respectable men of our city. We beheld the whole body of those officers forced, at length, from their seats, and driven, with jibes and blows, from the stage. And these officers were native Americans—men with grey heads—men known for long years among us, as gentlemen of reputation, philanthropy and exalted worth! And is New York to utter no loud voice of abhorrence towards this transaction? Is this hypocritical scoundrel Hughes, and his minions, to drill ranks of ignorant and vindictive followers—and send them forth to act as those wretches acted—and shall no note be taken of it? It is a blot and an insolent violation of our dearest and most glorious privileges. The whole city—the whole state—ought to rise up as one man, and let these jesuitical knaves, and their apt satellities, know what it is to feel the blast from an injured and outraged country."

Rhode-Islanders—Read this. Ponder seriously on it. Say—are you prepared to witness such scenes enacted in your little, and hitherto peaceful and prosperous State? Are you prepared to see a Catholic Bishop, at the head of a posse of Catholic Priests, and a band of their servile dependants, take the field to subvert your institutions, under the sanction of a State Constitution. If not, vote for the Constitution now presented to you, which is well calculated to protect you from such abuses. Roger Williams.

Another nativist broadside, this one taking a strident anti-Catholic tone, declaring that those who "value too highly your Christian profession, your Christian character, and your Christian principle" should vote down the people's constitution. Courtesy of Brown University.

A Movement Against All Law

Another broadside warned that the state "will become a province of Ireland: St. Patrick will take the place of Roger Williams, and the shamrock will supersede the anchor and Hope!" (referring to the state's symbol and motto).

One suffragist, writing from Tiverton, stated, "Men were called upon not to vote for a constitution, but to vote against Irishmen."

It should also be pointed out that this was a period of great tension between the black and Irish immigrant populations; neither group was accepted by the old Yankee establishment, which considered them both cut from pretty much the same cloth. Contemporary political cartoons depicted both the Irish and blacks as brutish, simian undesirables, shifty and ruled by their base instincts. In seeking the approval of native-born Yankees, the Irish immigrant population and the black community were really fighting over who would occupy the lowest rung of the societal ladder, and who wouldn't get to be on the ladder at all.

Dorr's family, stolid old Yankee patricians and conservative Whigs to boot, sided with the King administration and opposed the expansion of suffrage. And given that during all of this, Dorr still lived in the family mansion on Benefit Street, the awkwardness at the supper table can only be imagined. A younger brother expressed the opinion that Thomas had "not the right men to head such an enterprise—and no people on which you can depend to support you at all risks."

The younger brother may have understood the situation more clearly than the older.

5
ALGERINE LAW

The freemen's convention placed its constitution before the landowning voters of the state for a three-day vote beginning on March 21, 1842. The voters rejected it; 8,689 voted against it, 8,013 for it. The landowners' constitution lost approval by a mere 676 votes—a narrow defeat, but a defeat nonetheless. Dorr urged his followers to vote against the proposed constitution, which helps explain the large (for the time) turnout.

A few days later, on March 28, as the suffragists prepared for their elections under the people's constitution, Samuel Y. Atwell still sought to work within the system. He drafted a bill requesting that the General Assembly place the people's constitution before the legal voters who had previously rejected the landholders' constitution. "If adopted, it would be the law of the land," Atwell said. "If rejected, there would be an end to the matter, according to the principles claimed by the suffrage party." The bill was resoundingly defeated, as was his other bill for the extension of suffrage. With that out of the way, the sitting General Assembly went on to pass a law probably meant to bully the people into abandoning their cause, and to provide legal firepower if they did not.

> *An Act Relating to Offences Against the Sovereign Power of this State.*
>
> *Whereas in a free government it is especially necessary that the duties of the citizen to the constituted authorities should be plainly defined, so that none may confound our regulated American liberty with unbridled license; and whereas certain artful and ill-disposed persons have, for some time*

Algerine Law

THE LAST STRUGGLE OF THE
ENEMY.

Fellow Citizens, be on your Guard!

The *last plan* of the Enemies of the PEOPLE'S CONSTITUTION has been disclosed. It is *two fold*— ☞ To *induce* as many as possible to WITHDRAW THEIR VOTES, and put them in for the *Rotten Borough* Constitution—and to QUALIFY as many persons with real estate as will accept of it, for part of a day, to swell their list of votes. It is understood that several persons in this city of large wealth, have offered the necessary means, to any amount, to accomplish the object.

FELLOW CITIZENS!—You cannot be driven by threats or force from your opinions; much less be *bribed by money to sell your birthright of freedom, or the rights of your brethren.*

☞ Watch every movement of the desperate faction, who, despairing of success by an appeal to your reason and sense of justice, now seek to force upon you this Anti-Republican and odious Constitution, by such disgraceful means. Expose their machinations. Name the authors, and bring them promptly, as soon as discovered, to the bar of public opinion, that the finger of scorn may be pointed at them.

Let every man, who values his rights and the honor of the State, who has not yet voted, come forth and record his sentence of REJECTION against the Tory Constitution.

☞ Remember *to-morrow* is the LAST DAY. Hasten to discharge the duty you owe to yourselves, to your State, and to your country. Let not your majority be diminished by this last stratagem of the Tory Faction.

☞ TO THE POLLS—WITHOUT DELAY.

PROVIDENCE, Tuesday Evening, March 22d, 1842.

A Dorrite broadside calling for the rejection of the freemen's constitution, here referred to as the "Tory Constitution," calling to mind the struggles during the American Revolution. *Courtesy of Brown University.*

> *past, been busy with false pretences amongst the good people of this State, and have formed, and are now endeavoring to carry through, a plan for the subversion of our government under assumed forms of law, but in plain violation of the first principles of constitutional right, and many have been deceived thereby; and whereas this general assembly, at the same time that it is desirous to awaken the honest and well-meaning to a sense of their duty, is resolved by all necessary means to guard the safety and honor of the State, and, overlooking what is past, to punish such evil doers, in future, in a manner due to their offences.*

The Dorr War

The act deemed all meetings and elections held under the people's constitution "illegal and void," and anyone running for office under the "pretended constitution" would be "guilty of a high crime and misdemeanor," punishable by a $2,000 fine and a year in prison. Anyone elected and actually attempting to hold office would be guilty of treason and sentenced to life imprisonment.

It further specified that all offenses prosecuted under this act would be heard before the Rhode Island Supreme Court—which, remember, was a body handpicked by the General Assembly. This may be why no one at the time seriously questioned the act's legality, at least out loud, and it quickly became law.

The law's harsh nature drew comparisons to the despotic reign of the Dey of Algiers, a still-reviled ruler who had sheltered Barbary pirates and slave traders and tangled with Thomas Jefferson. Its opponents promptly dubbed this piece of punitive legislation the "Algerine Law." The *New Age*, the suffragist weekly, grumbled, "The Dey of Algiers has had his day; and Rhode Island is the last place in which the arbitrary doctrines of this ex-potentate can be revived with success or impunity."

Seeking to further fortify their position, Governor King fired off a letter to President John Tyler, hand-delivered to Washington, D.C., by several emissaries:

Providence, April 2, 1842

Sir: The state of Rhode Island is threatened with domestic violence. Apprehending that the legislature cannot be convened in sufficient season to apply to the government of the United States for effectual protection in this case, I hereby apply to you, as the executive of the State of Rhode Island, for the protection which is required by the Constitution of the United States. To communicate more fully with you on this subject, I have appointed… three of our most distinguished citizens to proceed to Washington, and to make known to you, in behalf of this state, the circumstances which call for the interposition of the government of the United States for our protection.

I am, sir, very respectfully,
Your obedient servant,
Samuel W. King
Governor of Rhode Island

Algerine Law

In a follow-up letter dispatched just a few days later, King further pleaded:

> *There is but little doubt that a proclamation from the President of the United States, and the presence here of a military officer to act under the authority of the United States, would destroy the delusion which is now so prevalent, and convince the deluded that, in a conflict with the government of this state, they would be involved in a contest with the Government of the United States, which could only eventuate in their destruction.*

King and other officials, now styling themselves the "Law and Order Party," made overtures to the state's alienated black community. While blacks were at least theoretically sympathetic to the suffrage cause, resentment still (understandably) lingered over the refusal to extend voting rights to them. King and his men felt that they could hold out the possibility of black suffrage in return for loyalty in the brewing conflict. As one observer at the time commented, the Law and Order men held out the possibility "not because it was their right, but because they needed their help."

Such maneuvering would lead some of the suffragists—now being widely referred to as the "Dorrites"—to derisively brand the Law and Order party the "nigger party."

While the sitting government—variously referred to as the Charter Forces, the Law and Order government and even the Algerines—was taking such aggressive measures, the Dorrites had a difficult time nominating candidates for their upcoming elections. Previously, the Law and Order government had had to admit that the Dorrites presented a very real problem; now, Dorr and his people realized the King administration was a genuine threat. Many who had supported the People's Convention and the resulting constitution now distanced themselves from the party. A number of men who were asked to run for office adamantly refused and turned their backs on the suffrage cause under the ominous shadow of the Algerine Law.

On April 11, 1842, Governor King received an answer from President Tyler, in which the chief executive refused to send federal aid. He deemed the "unhappy condition of things in Rhode Island" to be "questions of municipal regulation…with which this Government can have nothing to do." He further added that the federal government could not decide the "real or supposed defects" of the people's constitution, nor would it be "the armed arbiter" in the matter. King must sort it out for himself, but Tyler added, with a wink, that if the dispute became an insurrection:

The Dorr War

> *It will be my duty…to respect the requisitions of that government which has been recognized as the existing government of the State through all time past, until I am advised, in regular manner, that it has been altered and abolished, and another substituted in its place, by legal and peaceable proceedings, adopted and pursued by the authorities and people of the State.*

The suffragists sent Dr. James A. Brown, prominent member of the Rhode Island Suffrage Association, to Washington to plead the people's case before Tyler. He soon returned with a very different message.

"The president will never send an armed force to Rhode Island," he assured the association, "or in any other way attempt to prevent the people from obtaining and enjoying their rights."

In the age-old manner of political operators, Tyler had simply told each man what he wanted to hear.

Eventually organizing a slate of candidates, the people's party held elections on April 18, 1842. Thomas Wilson Dorr ran for governor, after three other men had refused the nomination. He won unanimously, running unopposed and receiving 6,359 votes. He knew full well that this placed him in the crosshairs of the Algerine Law.

Two days later, Samuel Ward King won another term as governor, beating his opponent, Thomas Carpenter, 2 to 1, polling 4,864 votes.

Each man now considered himself to be the duly elected governor of the state of Rhode Island.

With members of his own party distancing themselves from him and laws being passed to specifically punish his actions, Dorr now had to deal with the shocked disapproval of his family. A letter from his parents read:

> *If your heart is sensible to parental anguish, you will renounce your present course and restore to us a peace of mind which has for a long time been a stranger to us.*
>
> *May God in His infinite wisdom prompt you to a decision which can only restore you to the good opinion of your friends and fellow citizens whose esteem is worth the cultivation, and will preserve our grey heads from that shame and disgrace which will attend us if you persist, and which will hurry us sorrowing to the grave.*

6

The Two Governors

Rhode Island was now in a bizarre predicament, with two rival governments—one headquartered in Providence, the other in Newport—each headed by a man who considered himself the rightful, duly elected governor, and each organized under very different documents. It was almost inevitable that they should come to blows.

May 3 was Inauguration Day.

In Providence, the streets were thronged with Dorr's supporters, his detractors and the merely curious. A crowd of some two thousand people gathered in the West End at Hoyle's Tavern—at the present-day intersection of Cranston and Westminster Streets—to escort the people's governor to the East Side. At least two militia companies in full uniform and carrying loaded rifles were on hand, ready to protect Dorr from any attempts to arrest him. A brass band played as the procession made its way across Weybosset Bridge and arrived with great fanfare at the old statehouse on Benefit Street.

Until the impressive modern Rhode Island Statehouse atop Smith Hill, designed by McKim, Mead and White and crowned with the Independent Man, was completed in 1904, the General Assembly rotated among five different locations, one in each county. This is why, even today, one can find five different buildings across the state all referred to colloquially as "the old statehouse." Built in 1762, the building before which Dorr and his followers now stood had been the scene of various suffrage meetings and even the People's Convention—a fitting place for the first session of the people's legislature to convene.

But the building was locked.

The Dorr War

To add insult to injury, a light rain began to drizzle down on the crowd, which had been so jubilant and triumphant only a moment before. If one listened closely, he could probably hear King's charter government in Newport, laughing.

Dorr himself must have been livid at this turn of events. He would later fume that, had they gained entry to the statehouse, "right would have been confirmed by possession, the law and the fact would have been conjoined, and the new order of things would have been acquiesced in by all but a minority." As the rightful governor, backed by the duly elected legislature, they were "entitled to sit in the usual places of legislation, to possess and control the public property, and to exercise all the functions with which it was constitutionally invested. A government without power…was no government at all, and was destined to extinction." Dorr favored taking "vigorous measures" and was all for breaking into the building, but he was voted down.

Historians of the Dorr War have pointed to certain key moments, when, if things had gone differently, the whole course of the rebellion could have been changed drastically. This is the first of several such moments. There has been some discussion among historians that indicates that they agree with Dorr—taking possession of the statehouse would have placed them in a position of strength and led to greater acceptance among the populace, and the tide would have turned. This is certainly a possibility, but unfortunately, we will never know.

The disappointed and now damp people's legislature moved to a foundry still under construction on Dorrance and Eddy Streets downtown. Here, they convened their first session with as much dignity as they could muster—which, under the circumstances, couldn't have been much. The roof of the building was only half completed and afforded scant protection from the weather. More than one new government official got rained on.

The Speaker of the House of Representatives, Welcome B. Sayles, was sworn in. Sixty-six out of eighty state representatives were present, and nine of the dozen senators appeared and took their seats on a raised dais at one end of the chamber after being sworn in.

Dorr took the oath of office and delivered his inaugural address, acknowledging:

> *It is with no ordinary emotions that I proceed to discharge the duties imposed upon me by the constitution of this state…this is the first session of a legislature ever convened under a written constitution of government,*

> *proceeding from the people of Rhode Island…If the people of Rhode Island are true to themselves, the democracy of Roger Williams has this day been restored in the place where it originated. The sacred fire, so long extinguished, has been rekindled upon our altar. The sovereignty of the people has been vindicated. The distinctions of caste and privilege have been abolished.*

He proceeded to summarize the long struggle for constitutional reform, underscore his vision of popular sovereignty and affirm the rights of the people to form their own government. Eloquently and passionately, he stuck to the familiar suffrage talking points. The critical *Providence Daily Journal*, strongly sympathetic to the Law and Order government, dismissed the address as "a patchwork of his own speeches and articles in the *New Age*."

Dorr concluded his inaugural oration by declaring, "The laws should be made, not for the good of the few, but of the many; and the burdens of the State ought to be fairly distributed among its citizens."

That kind of talk led at least one historian, writing in the 1920s, to brand Dorr a "Socialist, or a 'Red.'"

One of the first orders of business was to repeal the Algerine Act passed by the Law and Order assembly, which Dorr and his people now saw as the previous, now-superseded assembly. They also proceeded to appoint various officials, pass resolutions and otherwise perform the usual business of a state government. They prepared a notice to President Tyler, informing him that Dorr was now the duly elected governor of the state and had assumed office.

George Thurber, a Providence apothecary and something of an alarmist strongly opposed to the suffrage cause, took a dim view of events. In his diary, he wrote:

> *This is a day big with fate—the inauguration of officers under the new constitution. They formed a procession to escort their governor, and such a procession! It seems as if all creation was put into a great cauldron, boiled, and the skimmings emptied into our good city. Such a rusty, motley miscellaneous crew I never saw. They mustered about 500 muskets, many of which were borne by boys. They organized in a vacant furnace on Eddy Street. Dorr read his message. They intend having the Court House tomorrow. There have been a great many drunken people in the streets and some pockets have been picked.*
>
> *May 4: Looked in at the foundry assembly for a short time. They are going on just as if they had the power to enforce their acts. They appointed a committee to receive the State papers. Guess they'll get 'um! They thought they wouldn't take possession of the State House. After transacting a great*

deal of business in a very short time they adjourned to meet next Fourth of July. Their whole proceedings are farcical in the extreme.

In Newport, King's newly sworn administration was not idle.

While Tyler had remained noncommittal when King applied for troops the previous month, sidestepping the quandary of choosing between rival governments, he did reinforce the garrison at Newport's Fort Adams. Approximately 183 troops arrived from other states, more than doubling the number of men stationed there. Each soldier was soon equipped with forty rounds of ammunition and two days' field rations and given orders to be ready for action with thirty minutes' notice. They were apparently given to understand that they were there to uphold the charter government. Tyler was quietly helping the Law and Order government prepare for war, just in case.

King's assembly also passed a new resolution, perhaps seeking Tyler's more open assistance:

> *Whereas a portion of the people of this state, for the purpose of subverting the laws and the existing government thereof, have framed a pretended constitution, and for the same unlawful purpose have met in lawless assemblages and elected officers for the future government of the state, and whereas the people so elected in violation of law, but in conformity to the said pretended constitution, have on the third day of May instant, organized themselves into executive and legislative departments of government, and, under oath, assumed the duties and exercise of said powers; and whereas in order to prevent the due execution of the laws, a strong military force has been called out, and did array themselves to protect the said unlawful organization of government, and to set at defiance the due enforcement of law, therefore,*
>
> *RESOLVED by the general assembly, that there now exists in this state an insurrection against the laws and constituted authorities thereof; and that, in pursuance of the constitution and laws of the United States, a requisition be, and hereby is, made by the legislature upon the President of the United States, forthwith, to interpose the authority and power of the United States to suppress such insurrectionary and lawless assemblages, to support the existing government and laws and protect the state from domestic violence.*

This appeal was sent the same day that Dorr sent the announcement of his inauguration to Tyler. Soon, both the Law and Order and Dorrite governments would dispatch delegations to Washington to plead their cases before the chief executive.

7
Unequal to His Situation

Beginning on May 4, the Law and Order government cracked down on its opponents with a barrage of arrests under the Algerine Law.

Daniel Brown, a representative from Newport, was arrested. Welcome B. Sayles, the people's Speaker of the House, was arrested and fined. Burrington Anthony, a close friend of Dorr who had been elected sheriff of Providence County, was likewise arrested, along with Dutee Pearce, another officer of the people's General Assembly. More officers, senators and representatives were arrested and fined over the next few days.

In a bold and dangerous move, the *Daily Express*, the daily edition of the *New Age* newspaper, published a notice of the arrests, along with the names and addresses of those who swore out the complaints and the justices who issued the warrants. Naturally, their critics saw them as furnishing a hit list.

"Do the men of the Suffrage Party approve of this?" the *Providence Daily Journal* demanded.

> *Do they agree that their fellow citizens, the judicial and executive officers of the State, shall be marked for the torch of the incendiary or the dagger of the assassin? If the wretched and unprincipled leaders of this foul conspiracy think that they can, in this manner, intimidate men from the discharge of their duty, they will find themselves greatly mistaken.*

Some anti-suffrage men had their barns burned, presumably by Dorrites, but as ever, the Algerines were more organized. A number of suffragists were fired from their jobs

The Dorr War

If anyone was intimidated, it was the Dorrites themselves. Members of the people's legislature resigned their positions with the government; while they may have supported the idea of popular sovereignty, they were not ready to face the consequences of Algerine Law. Many of Dorr's legislators put their hands in their pockets and strolled away nonchalantly, whistling innocently as they went and hoping no one was following them.

Within a few days, the wave of frightened defections caused the *Providence Daily Journal* to crow:

> *The revolution is in a state of suspended animation. Governor Dorr has fled or run away. Pearce is missing. Sheriff Anthony has absquatulated. The Secretary of State's Office is over the line and their headquarters nobody knows of. Their General Assembly has evaporated.*

The reason that Pearce and Anthony could not be found was that, after making bail, they proceeded to Washington as part of the delegation to Tyler. Dorr was unconvinced of the necessity of seeking the president's approval. Not only was this a state matter that, as such, did not come within the president's purview, but also Dorr felt himself to be unquestionably the lawful, duly elected governor of the state, so why should he need to appeal to Tyler? But bowing to pressure from what was left of his General Assembly, he left for Washington, a day behind Pearce and Anthony.

Fifty-two-year-old John Tyler of Virginia had been vice president under William Henry Harrison, and when Harrison died of pneumonia a month after his inauguration, Tyler became the first vice president to succeed to the presidency. This earned him the mocking title "His Accidency" from his many opponents. The story that he had been playing marbles at his home when news of Harrison's death reached him did nothing to help his credibility in Washington. Many suspected that the real power in the Oval Office was Secretary of State Daniel Webster, characterized as the puppet master who held the president's strings. Tyler hated former president Andrew Jackson almost as much as Dorr idolized him. The governor and the president were almost destined to clash.

Meeting together on May 10, Dorr found Tyler to be an unprincipled finger-to-the-wind politician; he described the president as "a very good natured weak man, unequal to his situation and having his mind made up for him by others" while "casually occupying the place of President."

While Tyler agreed with Dorr that this was a state matter and the federal government should not get involved, he had already made up his mind

to quietly back the King administration. The day before Dorr arrived at the White House, Tyler had sent an official reply to King, declining to send federal troops. But along with that letter, he included a "private and confidential" note:

May 9, 1842

Sir: Messrs Randolph and Potter will hand you an official letter; but I think it important that you should be informed of my views and opinions as to the best mode of settling all difficulties. I deprecate the use of force, except in the last resort; and I am persuaded that measures of conciliation will at once operate to produce quiet—I am well advised that if the general assembly would authorize you to announce a general amnesty and pardon for the past, without making any exception, upon the condition of a return to allegiance, and follow up by a call for a new convention, upon somewhat liberal principles, that all difficulty would at once cease. And why should this not be done? A government never loses any thing by mildness and forbearance to its own citizens; more especially when the consequence of an opposite course may be the shedding of blood. In your case, the one half of your people are in the consequences of recent proceedings. Why urge matters to such an extremity? If you succeed by the bayonet, you succeed against your own fellow-citizens, and by the shedding of kindred blood; whereas, by taking the opposite course, you will have shown a paternal care for your people. My own opinion is, that the adoption of the above measures will give you peace, and insure you harmony. A resort to force, on the contrary, will engender for years to come, feelings of animosity.

I have said here I speak advisedly. Try the experiment; and if it fail, then your justification for using force becomes complete.

Excuse the freedom I take, and be assured of my respect.

John Tyler

Tyler may have been dragging his feet in the hope that the whole matter would blow over and he wouldn't have to take decisive action. He may have avoided speaking and acting openly because he was unpopular in Washington and was still working to gain acceptance among both Democrats and Whigs. His states' rights philosophy may have discouraged him from using federal means to solve a state-level problem. Or he may have feared that openly backing what many denounced as a revolt may have repercussions in the

slaveholding states—Nat Turner's bloody 1831 slave revolt was anything but a distant memory in Tyler's native Virginia.

Whatever his reasons, Tyler was polite to the visiting Dorr, saying that if there was violence, then he would be forced to act, and any who resisted or acted against the federal government might be guilty of treason.

Dorr and his men left the Oval Office in frustrated disappointment. One wonders if they passed King's delegation in the hall on the way out. The situation was debated in both Congress and the Senate, but Dorr knew he could expect no help when the Senate refused to accept a letter from him as the governor, and when one senator loudly remarked that the Rhode Island rebels "ought to be hung!" he knew it was time to leave.

The debate over whether the federal government should intervene—or even if it had the right to—was soon dubbed the "Rhode Island Question."

Traveling to New York City, long a Democratic bastion, Dorr hoped to gain some much-needed popular support and recuperate from his failure in Washington. New Yorkers welcomed him.

In a tale that has no shortage of strange episodes, the visit to New York furnishes two.

The first was a secret meeting attempting to broker a compromise headed by none other than Secretary of State Daniel Webster. Dorr had already had enough of him in Washington and was extremely reluctant to meet him, but he eventually agreed. John Whipple, a member of King's delegation to the White House, was also in attendance.

Whipple suggested that the Algerine Law might be suspended and the charter government would remain in power while the United States Circuit Court decided the validity of the people's constitution. Dorr flatly denied the proposal. For him, the people's constitution was unquestionably valid, and besides, submitting the matter to the circuit court would probably put it in the hands of Pitman or Durfee or one of the other judges who had already decided against them and branded their actions as treason. And for Dorr, this whole meeting reeked of negotiating with the enemy; he would not compromise with the Algerines, especially as one part of their offer required that he never return to Rhode Island.

In another strange twist to the tale, the people's governor found himself courted and fêted by the leaders of New York's soon-to-be-infamous Democratic political machine, Tammany Hall. Founded in May 1789, the Society of St. Tammany, also sometimes called the Sons of St. Tammany, took its name from Tamanend, an Indian leader of the Lenape tribe (there is no Christian saint by that name). Members of the society were active

organizers in New York politics, and while the corrupt excesses of Boss Tweed were still years in the future, Tammany exerted its influence through a system of patronage and favors. Tammany was the place where everyone "knew a guy" who could get something done for them. By the 1840s, Tammany had begun to buy the loyalty of recent Irish immigrants with help finding housing or jobs, and as a result, the society had broad support among the city's blue-collar workers and was pretty much able to control New York City elections, which often influenced national elections in turn, well into the twentieth century.

Dorr spent the afternoon of Friday, May 13 (which had not yet come to be viewed as an unlucky date), shaking hands with various Tammany men at Howard's Hotel, their unofficial headquarters. It was announced that "His Excellency, Governor T.W. Dorr, of Rhode Island, has consented to attend a performance at the Bowery Theatre this evening, accompanied by the Rhode Island Delegation and several other distinguished personages." The next day, he was warmly greeted at Tammany Hall itself on East Fourteenth Street, where he was called upon to deliver a fiery speech. Unfortunately, no draft or transcript of the speech was published or otherwise circulated, but Dorr seems to have stuck to his usual points and exhorted the crowd to support his efforts to uphold the people's will, professing that he was fully prepared to become a martyr to his cause—"a profession which is likely very soon to be put to the test," the *New York American* newspaper commented darkly. He received many promises of assistance if the federal government dared interfere.

During his few days in New York, he made the acquaintance of "Big" Mike Walsh, an Irish-born rabble-rouser and political adventurer who headed the "Spartan Band," a fractious Tammany faction dedicated to the workingman. Walsh was a crusading reformer who debated with his fists as often as not; he and the rest of his club-swinging Spartans once broke into the meeting of a rival group and chased them from the hall. Big Mike fit the popular stereotype of the pugnacious, hard-drinking Irishman. He was equally hated and revered and pledged his support to Dorr.

While in New York, a man—we don't know who, possibly a Tammany man—presented Dorr with a sword, which he said belonged to his brother, an officer who had been killed serving under General Andrew Jackson in Florida. Details of the sword's history are sketchy at best, but Dorr received the sword with gratitude.

Taking his leave, Dorr prepared to return to Rhode Island, reinvigorated and ready for the hard tasks ahead. He was given a boisterous send-off by his

new Tammany allies. Graciously refusing the offer of a military escort back to his home state, he assured them

> *that the time may not be far distant, when I may be obliged to call upon you for your services in that cause to which you would so promptly render the most efficient aid—the cause of American citizens contending for their sovereign right to make and maintain a republican constitution and opposed by the hired soldiers of the general government.*

A parade escorted Dorr to a steamboat bound for Connecticut, along with a brass band and a team of firemen towing a twelve-pounder cannon. The size of the crowd has been variously reported, perhaps reflecting the sympathies of those doing the counting; some sources place the number at around five hundred, while the *New York Evening* saw the crowd as a "vast civic procession which numbered thousands of our most worthy, industrious and respectable citizens." The *New York American* reported:

> *We never, in our lives, saw a worse looking set than the government escort— the Five Points could not have beaten it at an election. The governor sat bareheaded, looking as grave as an owl. He is a man of nerve and no mistake—any but such a person would have broken down in a fit of laughter at the absurdity of the thing.*

8
THERE IS DANGER HERE

"Mr. Dorr's recent proceedings have been of so extravagant a character as almost to extinguish the last hope of a peaceable result," Samuel Ward King remarked upon hearing of Dorr's visit in New York, "and yet I cannot but believe that much is meant for effect and for purposes of intimidation. I certainly hope that such may be the case, though the recent proceedings in New York may have excited new feelings and new desires."

Rumors of a possible compromise had circulated in Dorr's absence, but it was clear that there would be no compromise when Dorr returned to Providence, no doubt exhausted by a whirlwind week and with a head swimming with promises of support. He had taken a steamer to Stonington, Connecticut, where he was met by a throng of supporters before boarding a train for Providence. Another cheering crowd of some three thousand greeted him as his train pulled into the station. Many of the crowd members were armed, and a number of loyal militiamen were there to welcome their governor home. Ushered into an open carriage, Dorr paraded triumphantly through the streets of the city and was eventually brought to Sheriff Burrington Anthony's house on Atwells Avenue.

By now, he was no longer welcome in the family home; the doors of the Dorr mansion on Benefit Street were closed to him. Sheriff Anthony offered his hospitality to the governor, and Anthony's house would soon become known as Dorr's headquarters, even though he would only spend a night or two there.

Standing up in the carriage, Dorr addressed the crowd. As with his speech before the men of Tammany Hall, we have no transcript, but we can piece it partially together from the several often-conflicting later reports.

A HORRIBLE PLOT
DISCOVERED!!

A most foul and ferocious plot to butcher the people of Providence, has just come to light. Evidence, conclusive, and of the very highest authority, can be produced to establish the following statement, viz:—that THOMAS W. DORR did, previous to his leaving this city, write a letter to LEVI D. SLAMM, Editor of the New Era, of the city of New-York, requesting him to raise *five hundred men* in that city to be sent armed to Rhode-Island! This letter was shown by Mr. Slamm to a gentleman of this city, who is a strong Suffrage man, and was supposed to be in the interest of DORR, and his course of violence and blood. In a spirit of independence and good citizenship, which does him great honor, he informed DORR, upon his arrival in New-York, that he should go with him in no forcible measures, and communicated to him the knowledge he had of his (Dorr's) application to Slamm, which Dorr acknowledged to be true.

We insert the following statement of two individuals of this City of undoubted credibility to establish the general fact that DORR has made such an application.— A more particular statement will be forthcoming if th fact is denied.

"We hereby state that we returned from New York this morning, and while there learned from unquestionable authority, that THOMAS W. DORR, before leaving this city, made an application upon LEVI D. SLAMM, Editor of the NEW ERA of the city of New York, for 500 men to be raised in New York and sent armed to Rhode Island.

Providence, May 14, 1842.

J. B. NICHOLS,
C. C. POTTER.

At a time when all parties concur in the opinion that a written Constitution should be established which shall secure a liberal extension of suffrage and equalize representation in the Legislature of this State, and when all are willing and ready to call a State Convention to accomplish these high objects as soon as the public mind is in a condition of calmness united to cool and dispassionate deliberation upon a subject so important to the State, will any good citizen, no matter what are his opinions upon the question of suffrage, longer countenance the violent, revolutionary and ferocious course of action marked out by DORR and a few other desparate men? The time has now arrived when every man, who has been in any way identified with the proceedings of DORR, but who loves his State and has any regard for her peace, her honor and her future well being, to speak out and let these violent and ferocious men who would bring here armed ruffians from the city of New-York to butcher their fellow-citizens, understand in language not to be misunderstood, that they approve no such measures, and will have no further fellowship with such leaders. No man who has any regard for his own reputation as a good citizen, will be willing to rest under the imputation of having participated in such a course of proceedings. Let, then, every man who has been associated with Dorr, heretofore, come out and denounce, as it deserves, such a course of violence and blood.

We now ask the honest and peaceful portion of the Suffrage Party of this State, to reflect upon the position which this reckless and infuriate demagogue is urging them to assume. Do they desire to associate themselves with a band of lawless and ferocious ruffians brought from the City of New York to butcher their fellow citizens.

A panicked broadside warning that "evidence, conclusive, and of the very highest authority" had been obtained that Dorr planned to lead a bloody attack on Providence with the aid of five hundred "lawless and ferocious ruffians" from New York City. *Courtesy of Brown University.*

There Is Danger Here

As a lawyer, Dorr was no stranger to public speaking (even if Abraham Payne had dismissed him as "a dull speaker") and making a case before a jury, stressing a case's particular strengths, glossing over its weaknesses and generally engaging in what has come to be known as "spin." Over the course of forty-five minutes, in a speech described as "well timed and eloquent" and also "furious and inflammatory," he renewed his dedication to the people's cause. He claimed to have five thousand New York men waiting to assist him at a moment's notice should the federal government dare interfere.

"He looked more like a fiend than a man," one onlooker, a longtime supporter, later said.

> *The day was dusty, and he was covered in dust; his hat was off; his beard was long and his hair was blowing in the wind. He was one of the most fierce-looking men I ever saw. He did not look like the same person whom I had so long known.*

Brandishing the sword, Dorr repeated the story he had been told in New York, adding that the sword had been bloodied in the name of liberty once before, and he would not hesitate to bloody it again if needed. The *Providence Daily Journal*, ever his critic, scoffed:

> *Mr. Dorr made a great flourish…about a sword, which he drew and brandished in a most fearful manner, and told a great story about its having belonged to an officer who fell fighting for his country. This sword belonged to a Lieutenant named Reill who died of dysentery on the passage from St. Mark's to Providence, and all the blood that was ever upon it would not wet the point.*

Where the *Journal* obtained this supposed information is unknown.

A warrant for Dorr's arrest had been issued days before, and it is likely that the sheriff carrying it was somewhere in the crowd. But with discretion being the better part of valor, he made no attempt to arrest the people's governor that day.

As the crowd dispersed, Dorr retired indoors with Anthony and several others to convene a council of war.

On May 12, while Dorr was in New York, King had followed Tyler's advice and offered amnesty to those targeted by the Algerine Law. Those who took advantage of the offer were required to renounce the people's government and swear allegiance to the charter government. Dorr must

have been appalled when he found that a number of his legislators and other supporters had done so.

In a move that seems to indicate an increasing desperation, Dorr once again advocated "vigorous measures" and decided to forcefully seize state property. He had been outvoted when he suggested breaking into the statehouse, and it was probably easier to get his way now that fewer followers surrounded him. After much debate in Anthony's house, they laid plans to storm the state arsenal nearby and take possession of the weapons stockpiled therein.

Accordingly, a detachment of men was sent across town to the United Train Artillery Company on College Hill to requisition a pair of cannon there. Many of the state's militia units, including the United Train Artillery, were loyal Dorrites, made up of the same mechanics and Irishmen who had voted him into office in the first place. When Dorr's men appeared with loaded muskets and demanded the cannon, those in charge of the artillery company knew it would be unwise to seem like pushovers or—worse—sympathizers, so they engaged in a halfhearted charade of resisting. Dorr's men were told the key to the building was nowhere to be found, even though it was soon produced and the two guns handed over. Reacting to the whole episode with all the gravity of a neighbor lending a ladder, the men of the United Train instructed the others to return the cannon as soon as they were finished with them.

The cannon thus acquired were six pounders. Cannon of the period were rated by the weight of the cannonballs they fired. While a six pounder is a smaller gun—navy ships of the period could have sported eighteen pounders or even larger—it is a good choice for a mobile field artillery. These particular cannon, according to legend, had been seized from British General Burgoyne after his defeat at Saratoga during the Revolution. How they ended up in Rhode Island is unclear to say the least.

The men brought the guns back across town and positioned them in front of Burrington Anthony's house on Atwells Avenue, where, along with several other piece of artillery, they served as a silent warning to the forces of the charter government.

The planned attack on the arsenal was anything but a covert operation, and word spread among the Algerines almost as quickly as it did among the Dorrites. Dorr appealed to his people to arm themselves and prepare for action, and so did Samuel Ward King. By the afternoon of May 17, the city was plastered with broadsides issued by King, reading, "To the Citizens of

There Is Danger Here

Another A HORRIBLE PLOT
To Drench the State of Rhode Island with the Blood of its inhabitants!

A most foul and ferocious plot to MURDER the inhabitants of this State, has recently come to light.

Evidence conclusive, and of the very highest authority can be produced to establish the following statement, viz:

That SAMUEL W. KING did, a short time since, write to John Tyler, of Washington, requesting him to forward to this State, a body of armed men (principally foreigners) to *Shoot down the peaceable inhabitants* of this State, for having dared to exercise the dearest rights of free citizens, in adopting a Constitution, based upon the following *Republican Principles,* viz: " *That all political power and sovereignty are originally vested in, and of right belong to the People. That all free Governments are founded in their authority, and are established for the greatest good to the whole number. That the People have therefore an inalienable and indefeasible right, in their original, sovereign and unlimited capacity, to ordain and institute government, and, in the same capacity, to alter, reform, or totally change the same, whenever their safety or happiness requires.*"

For having dared to carry out these principles, SAMUEL W. KING, under the tutelage of a few such men as RICHARD K. RANDOLPH, JAMES FENNER, and SAMUEL AMES, has written to John Tyler, as above.

The PEOPLE of this State feel fully competent to put down any intestine faction, whose object is to subvert their government; but if the plotters of the above conspiracy, succeed in obtaining from abroad a sufficient number of *hired mercenaries,* to wrench the power from the PEOPLE, we shall then, and not till then, call on every patriotic lover of freedom, wherever he may be found, to render us any and every assistance in his power, in opposing such *foreign foes,* and sustaining the government of the PEOPLE.

Providence, May 16th, 1842.

A Dorrite broadside also claiming to have "evidence, conclusive, and of the very highest authority" that Governor King had called for federal troops "to shoot down the peaceable inhabitants of this state for having dared to exercise the dearest rights of free citizens, in adopting a Constitution." *Courtesy of Brown University.*

Providence!!! You are Requested FORTHWITH to Repair to the State Arsenal and Take Arms."

That same day, the *Providence Daily Journal* wondered, "How long will honest men be deluded into sanctioning his course, participating in his crimes, and rendering themselves liable to his punishment?"

The arsenal in question was a stout two-story stone building at the south end of the Dexter Training Ground, one mile away from Dorr's headquarters. Its eighteen-inch thick walls, iron doors and windows made it a secure place to stow arms and ammunition. To the east of the arsenal was a prosperous and growing residential neighborhood; to the west lay the mills and factories of Olneyville. Arsenals were often strategically placed between residential and industrial neighborhoods to help discourage workers from striking and to supply a means of dealing with them if they did.

The Dexter Training Ground is part of the Dexter Donation of 1824. Ebenezer Knight Dexter was a wealthy and philanthropic merchant who was also appointed United States marshal for the state in 1810. Dexter died in 1824 at the age of fifty-two, leaving two large parcels of land to the city—the ten-acre Dexter Training Ground on the West Side and the land that would become the Dexter Asylum (for the poor, not the insane) on the East Side. His will stipulated that the training ground must always be open for the use and enjoyment of the public, and furthermore, there should never be any executions held there. (Executions were still public entertainment in some states.) In 1893, a statue of E.K. Dexter was erected at one end of the park that bears his name. The words chiseled on its base could just as easily apply to T.W. Dorr: "Leaving nothing but a headstone to mark our passage through life does not make the world better. They live best who serve humanity the most."

Coincidentally, the Dexter Training Ground had been the site of a major suffrage rally on the previous July 5.

By nightfall on May 17, the arsenal was packed with loyal Law and Order militiamen and volunteers, all armed and ready for a fight. The building stored over two thousand rifles, muskets, ammunition and several pieces of heavy artillery. Among the many men who came to reinforce the garrison that night was Thomas's own father, Sullivan Dorr, along with his younger brother, Sullivan Jr., and brother-in-law, Samuel Ames, the quartermaster general married to Dorr's sister. Governor King paid a brief, nervous visit to the arsenal to inspect the troops before departing in haste.

At 1:00 a.m., a gun was fired outside of Burrington Anthony's house, a signal to the Dorrites to assemble and ready themselves. A group of

There Is Danger Here

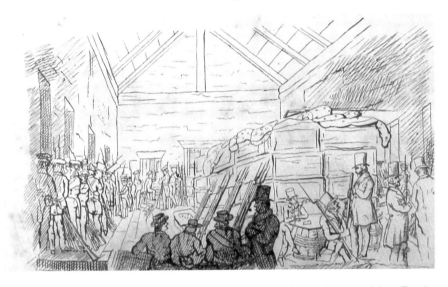

A lithograph depicting the many volunteers mustered out to defend the arsenal from Dorr's attack. *Courtesy of Russ DeSimone.*

about three hundred men gathered, bolstered by groups of volunteers from Pawtucket and as far away as Woonsocket. Dorr gave command of the troops to Colonel Wheeler, and about 1:30 a.m., the little army began its march to the arsenal a mile away on Cranston Street, with Dorr and Wheeler leading the way.

As they marched through the streets of Providence's West End, worried onlookers, up late to witness the spectacle, gawked from their windows. This was, after all, a residential neighborhood. Some residents, fearing the worst, hid in their cellars. The Dorrites may have lost a few men along the way, as some realized the seriousness of their undertaking and slipped off into the night. Dorr's force had dwindled slightly by the time they reached the Dexter Training Ground about 2:00 a.m. The night was humid, and the arsenal was shrouded in a damp fog, its whitewashed walls looming starkly in the darkness.

Dorr signaled his men to fan out along two sides of the building and had the pair of cannon wheeled into position. While not large guns, the cannon could still do serious damage to even a stone building such as the one they now stood before. Men placed themselves on either side of the entrance, weapons in hand, ready to rush in if the door was opened. Colonel Carter was sent to demand the surrender of the arsenal's commander. Carter approached with a flag of truce—a white handkerchief tied around his sword—and banged

The Dorr War

Dorr's attack on the arsenal failed when his cannon proved to be useless, and his men abandoned him. *Courtesy of Brown University.*

on the stout iron door, calling for the garrison to surrender in the name of Colonel Wheeler and Governor Dorr.

The defiant voice that came from within belonged to Samuel Ames. He shouted back that he had never heard of a Colonel Wheeler and knew of no such person as Governor Dorr. He then added that he had enough men and ammunition at his disposal to blow the rebels to hell, and he would not hesitate to defend his post.

Carter returned to Wheeler's side, shaking his head.

"What did he say?" Wheeler asked.

"What the devil do you think he said?" Carter replied.

With their attempted parley a failure, the Dorrites prepared to attack. From behind the arsenal's door, they could hear the heavy artillery on the first floor being moved into position and loaded.

Peering out a second-floor window, one man leaned over to Sullivan Dorr Jr. and asked, "It can't be possible that your brother means to fire on this building when he knows that you, his father, and his uncles are all in it?"

"I guess you are not acquainted with the breed," the younger Dorr replied with grim calm.

Many in Dorr's little army must have assumed that the arsenal would quickly surrender, but now that an actual assault was imminent, their courage failed them. They were, after all, about to attack a fortified building housing an armed force of at least equal size to their own. Colonel Dispeau, commanding officer of the Pawtucket troops, declared he had come to be a military escort, not a military corpse, and ordered his men to withdraw. They caught Carter's eye as they retreated.

"Where do you think you're going?" Carter demanded.

"There is danger here!" Dispeau shouted back.

"How can you expect to go to war without there being danger?" Carter called as the Pawtucket men vanished into the misty night.

There Is Danger Here

Dorr gave the order to fire the first cannon. The man in charge of the gun called clear and applied the smoldering match as others nearby turned their heads and blocked their ears…and nothing happened.

Dorr spun around and ordered the second cannon fired. The second gun flashed and boomed but failed to actually fire. Both guns were hastily checked and reloaded but only smoked and flashed upon the second attempt at firing.

To this day, historians debate why both cannon failed. Perhaps the antique pieces were simply too old. Perhaps the misty night had dampened the powder, rendering it useless. Perhaps, as Dorr seemed to believe in the heat of the moment, they had been sabotaged—spiked or plugged by a traitor in the ranks.

The attack on the arsenal presents another of those "if" moments cited by historians. If the cannon had gone off and the men guarding the arsenal had truly felt under attack, there would probably have been serious bloodshed. The Law and Order men were better equipped and sheltered behind stone walls, not exposed out on the open ground.

But there was no bloodshed that night. The men of the arsenal held their fire, and as the fog thickened, Dorr's men were routed and deserted him, leaving him with only a handful of supporters. Realizing he had failed miserably, the people's governor sounded the retreat as the sun began to rise.

9

NOW ASSEMBLED IN ARMS

Dorr and what little was left of his force quickly made their way back to Burrington Anthony's house, arriving just after sunrise. There, a messenger handed him a letter informing him that nine representatives and two senators of the people's legislature had resigned. An armed attack was too much for them, and they could no longer support what had now become a violent revolution. The bungled attempt on the arsenal would cost Dorr dearly over the next few days, as more resignations followed and more and more supporters turned their backs on him.

About 9:00 a.m., after word of the fiasco spread throughout Providence, Samuel Ward King, accompanied by some seven hundred men and a dozen pieces of artillery, came down Atwells Avenue. Anthony's home stood atop a slight hill, and several cannon had been arranged in front of the house, aimed down into the street. King's approaching force hesitated when they noticed several other cannon on a neighboring hill, likewise pointed at them.

A brief but tense standoff ensued, as King's men positioned their ordnance and threats of violence were hurled back and forth. The Dorrite guns were withdrawn, and King and his troops stormed Anthony's house, waving an arrest warrant and demanding that Dorr be handed over immediately.

Burrington Anthony swore on his honor that Dorr had been gone for some time.

Knowing that the Algerines could arrive at any moment, and fearing for his safety, Anthony had strongly urged Dorr to flee shortly after his return from the arsenal. Faced with the recent desertions and the possibility of arrest and prosecution under Algerine Law, Dorr had reluctantly agreed.

Now Assembled in Arms

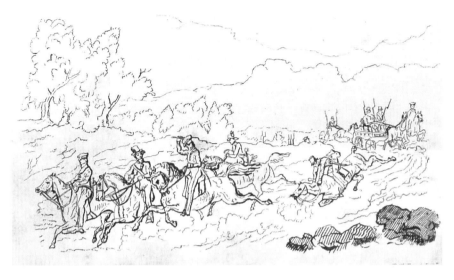

Algerine cadets in hot pursuit of the fugitive people's governor. Luckily for Dorr and unluckily for them, they set off in the wrong direction. *Courtesy of Russ DeSimone.*

The conscientious Dorr spent a few moments arranging his papers. Placing much of his personal business into Anthony's hands—mostly things relating to his positions on the school board and the bank—he took flight. A squad of mounted Algerine cadets set off in pursuit, but in the wrong direction. Later that day, Dorr reached Woonsocket, where he had numerous supporters, and spoke briefly of another attempt to take the arsenal, but he soon abandoned whatever plans he was considering and left the state altogether.

The tide had now turned against the people's cause. What had started as a popular movement with widespread support had now become a revolutionary position held by only a small band of extremists and true believers. The suffrage cause left a bitter taste in the mouths of many who had once supported it and its leader. Aaron White, one of Dorr's friends and allies, would soon write to the fugitive governor:

> *Your idea of using force must be abandoned entirely; there is no hope in that remedy now. I verily believe that if you were to come on with 1,000 men to aid the suffrage party just now, you would have to fight the suffrage men, just so completely have the minds of many been turned by recent misfortunes…I can hardly find a suffrage man in the city with whom to advise or consult, so completely have we been defeated.*

> **UNITED TRAIN OF ATILLERY.**
>
> It is not true that we willingly surrendered our pieces yesterday to Mr. Dorr's Volunteers. They were taken without our consent or knowledge.--- Our Company is warned to meet at 10 o'clock this morning, to retake them. **W. T. HOPKINS,**
> Clerk U. T. Artillery.
> Providence, May 18, 1842.

The United Train of Artillery denied that they were Dorrite sympathizers and insisted that their cannon had been taken without their consent. Neither statement was true. *Courtesy of Brown University.*

King offered a reward of $1,000 for Dorr's capture and appealed to the governors of Connecticut and Massachusetts for Dorr's extradition, should he be found within their borders. King also took advantage of Dorr's absence to clean house, continuing the pogrom of arrests under the Algerine Law, organizing new loyal militia units and disbanding two whose loyalty he found questionable. The United Train Artillery Company was one.

Rumors and speculations were carelessly bandied about, starting the morning after the arsenal debacle. The *Providence Daily Journal* explained:

> *There is but one possible excuse. Mr. Dorr has frequently, in years past, given evidence of mental alienation, and, at one time, almost positive proof of it. The excitement of his recent position, the prospect of prison before him, the indomitable obstinacy which forbade him to turn back, all of these, we charitably believe, have unsettled his intellects, and rendered him in some degree irresponsible for the atrocities which he has endeavored to bring upon his native state.*

Clearly, for the *Journal*, anyone fighting for the people's rights must be crazy. The same issue outlined Dorr's supposed plan to capture Brown

University after taking the arsenal, establishing his barracks there. He would then occupy the market house before embarking on the next, unspecified phase of his campaign. "He believed," the *Journal* wrote, "that the whole government would be overthrown, and that he would rise on its ruins." This may have borne at least some resemblance to the actual plan; the *Journal* may have been getting its information from supporters who had turned away from the cause.

The *New York Express* soon weighed in, reporting what it alleged were the numbers for the episode: "Killed: 0; Wounded: 0; Scared: 780; Fainted on the Battle Ground: 73; Women in hysterics: 22; Governor Missing: 0."

A New York Whig commented that Dorr's cannon failed to go off, so the people's governor "went off himself in the middle of the night."

There was nervous speculation that Dorr planned to return to Rhode Island leading an army of mercenaries and desperadoes gathered from neighboring states. These soldiers had supposedly been rallied under the battle cry of "Beauty and the Banks!"—which is to say, promises of women and money.

In Washington, Senator Sprague, no friend of the suffrage cause, declared, "There is an effort by Dorr and a large number of desperate men out of the state to invade it and take possession of it at all hazards." We don't know where he was supposed to be obtaining his information.

Tyler was "slow to believe" such wild rumors, but an unknown operative was sent by Daniel Webster and others to report back on the situation. According to the mysterious emissary's findings:

> *Governor King and his council alone of all intelligent persons with whom I have consulted fear an eruption upon them of an armed force to be collected from other states…the supposition that Rhode Island is to be invaded by a foreign force, when that force would neither be led or followed by any considerable number of people in the state, does not seem, to say the least, a very reasonable one.*

Still, this lukewarm report did not stop Tyler from visiting Rhode Island to meet with King and other officials and assess the situation firsthand. Strangely, biographers do not even mention Tyler making any visit to the state, but George Thurber, the anti-Dorr apothecary, wrote in his diary on June 15:

> *The President is very ordinary looking with an enormous hooked nose, which is perpetuated in his son. He rode in a barouche drawn by four greys,*

The Dorr War

accompanied by the Mayor and his son. As he rode through the streets he returned what salutations were given him, but there was no spontaneous burst of enthusiasm. People seemed to come more from curiosity to see the man than to welcome the President.

But Tyler's visit did not produce the results King was hoping for; there were still no federal troops to be offered.

While the majority of the people's legislature and upper-class supporters had washed their hands of him, Dorr did still have some diehard allies among the blue-collar mechanics who had been behind him from the beginning. During the month of June, perhaps clinging to the romance of a lost cause, they held numerous rallies and military processions in hopes of paving the way for their hero's return. There was talk of reconvening the people's legislature, if a suitable site could be found. They soon began to gather at Chepachet, a small village that was part of the town of Glocester in the northwest corner of the state, and dig in for a confrontation.

Four men passing through Chepachet were captured by Dorrite loyalists and accused of being Algerine spies; two of the men actually were. They were force marched to Woonsocket, some miles away. One of the men was overweight and slow-moving and was encouraged to keep up with the others by being jabbed with a bayonet. Reaching Woonsocket, they were released the next day and returned to Providence. They reported that an armed force had gathered, and a kind of martial law had been declared in the village. The Dorrites had fortified Acote's Hill in the village. The men's captors spoke of upholding the people's constitution and maintained that two thousand men would arrive on the scene by sunset, ready to do battle with whatever force the Algerines might send.

Realizing that something serious was afoot, the General Assembly took stern measures.

On June 23, it called for another constitutional convention, to be held in September. It allowed blacks to vote for delegates to the new convention, thereby swaying many of them away from the Dorrite cause. "There is not so much scolding about letting blacks vote as expected," one observer remarked. "They would rather have the negroes vote than the damned Irish."

The General Assembly floated the idea of abolishing the property requirement that had proven to be such a bone of contention. In so doing, King and his General Assembly showed themselves to be more flexible and willing to compromise than the people's governor had ever been. Several of Dorr's friends and former supporters came out in favor of the proposed convention.

Now Assembled in Arms

Given the activity at Chepachet, a failed attempt by some Dorrites to seize some cannon in the town of Warren, and renewed talk of Dorr's imminent return, the Algerines called out the troops. Artillery companies from Newport, Bristol and Warren reported for duty, being transported up Narragansett Bay by a steamer, which then departed to bring more. Armed men marched to Providence or arrived by train. By Saturday, June 23, 1842, a force of some twenty-five hundred to three thousand soldiers was encamped in the city, placed under the command of West Pointer William Gibbs McNeil. Included among that number was a company of carabineers from New York, carrying six-barrel Colt carbines; ironically, King had not hesitated to call on "foreign" troops, the very thing he had feared Dorr was about to do. A band of sixty-five sea fencibles—naval militia—arrived, bringing with them a massive Paixhan gun, a cannon that fired explosive thirty-two-pound shells. The men were billeted around the city, including the College Building (today's University Hall) on the Brown University campus.

While Tyler had refused to send troops, he made sure that the forces gathered by King were well supplied. Crates of United States military-issue muskets and ammunition soon arrived. They were stockpiled at the customhouse in downtown Providence and distributed to the men from there.

As troops massed in the city, the mayor enforced a curfew, and on June 25, the General Assembly in Newport declared martial law. Armed guards now patrolled Providence's streets.

An Act Establishing Martial Law in This State

Be it enacted by the General Assembly as follows:

Section 1: The State of Rhode Island and Providence Plantations is hereby placed under martial law, and the same is declared to be in full force until otherwise ordered by the General Assembly, or suspended by proclamation of his Excellency the governor of the State.

I do therefore issue my proclamation, to make known the same to the good people of the state, and all others, that they may govern themselves accordingly. And I do warn all persons against any intercourse or connexion with the traitor Thomas Wilson Dorr, or his deluded adherents, now assembled in arms against the laws and authorities of this State, and admonish and command the said Thomas Wilson Dorr and his adherents immediately to throw down their arms and disperse, that peace and order may be restored to our suffering community, and as they will answer to the contrary at their peril. Further, I exhort the good people of this State to aid

> **State of Rhode-Island and Providence Plantations.**
> *In General Assembly, June Session, 1842.*
> An Act establishing Martial Law in this State.
> Be it enacted by the General Assembly as follows :
> Sec. 1. The State of Rhode-Island and Providence Plantations, is hereby placed under Martial Law ; and the same is declared to be in full force, until otherwise ordered by the General Assembly, or suspended by Proclamation of his Excellency the Governor of the State.
> True copy---witness,
> **HENRY BOWEN, Sec'ry.**

Broadsides declaring martial law were plastered all over the state as King called out the troops and prepared an attack on Chepachet. *Courtesy of Brown University.*

> *and support by example and by arms, the civil and military authorities thereof in pursuing and bringing to condign punishment all engaged in said unholy and criminal enterprise against the peace and dignity of this State.*
> Samuel Ward King

On Monday, June 27, McNeil, headquartered at the Tockwotten House, issued orders to his forces, now some thirty-five hundred strong. The Kentish Guards were sent to Pawtucket to cut off possible invasion from Massachusetts. The Westerly Infantry was sent to patrol the southern border with Connecticut. The Providence City Guards—the closest thing at the time to a police force, with their ranks now filled out with over two hundred new black recruits who had joined the Algerine cause—watched the bridge over the Seekonk River. McNeil also ordered men into position in Woonsocket, Scituate and Greenville, all located within striking distance of Glocester.

The main force of the army was to march the sixteen miles to Chepachet and take the Dorrite encampment atop Acote's Hill.

10
Acote's Hill

Chepachet is a village in the northwestern corner of the state, not far from the Connecticut border. The name is supposedly Pequot for "where rivers meet." Then, as now, it lay on a well-traveled road leading north into Massachusetts, which made it a busy place for such a small village. Exact numbers are hard to come by, but the population could not have been more than a few hundred.

Today, Acote's Hill is a cemetery, but in the summer of 1842, the only grave on the hill was that of an itinerant peddler, known only as Acote, who had died under mysterious and suspicious circumstances and was now buried somewhere on the rise. The rest was open space on a gently sloping hill.

Thomas Wilson Dorr, the people's governor, returned to Rhode Island in the early morning hours of June 23, crossing the Connecticut border under cover of darkness and reaching Acote's Hill about 2:00 a.m. He had not chosen the site. Jedediah Sprague, owner of a nearby tavern, a longtime Dorrite and the general of a volunteer unit, had suggested it and pushed hard for it. Sprague insisted it was a perfectly suitable location for recalling the people's legislature and defending it, if necessary, against the Algerines.

It is difficult to know exactly what may have gone through Dorr's mind as he inspected the encampment and took stock of the situation. If he expected to find his legislature waiting for him with a large, well-organized army of fighting men ready for action, he must have been bitterly disappointed.

Not a single remaining member of his government had come to meet him on the hill, and while over one thousand people had descended on Chepachet, the vast majority were simply curious gawkers who came to see

what was happening in the sleepy little village. The actual number of Dorr supporters did not number more than three hundred, at the most.

Those men were grouped into volunteer units sporting such colorful names as Dorr's Invincibles, the Pascoag Ripguts, the Johnston Savages and my personal favorite, the Harmonious Reptiles. But the volunteers were poorly organized, trained and equipped. There were several cannon on the hill but little ammunition to go with them, and much of that was the wrong size for the guns. Someone had gathered a pile of metal scraps, evidently intended to serve as ammunition. Looking over the feeble ordnance, Dorr must have been sharply reminded of the disastrous attempt on the arsenal, when the guns failed. A hastily dug breastwork raised along two sides of the hilltop was evidence of a halfhearted attempt at fortification. Some overzealous Dorrites had outraged a local man by digging up his garden in their efforts to fortify their location.

Instead of the much-feared army of allies from other states, the only outside arrivals were Big Mike Walsh and a dozen of his Spartans.

A few years later, Dorr would recall that Acote's Hill "was commanded on one side, at a short distance, by a superior elevation of land; exposed on

Acote's Hill in Chepachet, the site of the Dorrite encampment, is a graveyard today. The location of Acote's grave is lost to history. *Photo by Robert O'Brien.*

another side and overlooked by an eminence, from which it could be swept by heavy artillery." He was a lawyer, not a general, but it didn't take him long to realize this was "an untenable position." At least it was only a few miles from the Connecticut line, in case he had to run.

Thomas Dorr was an idealist and an optimist. For over a year, he had been fueled by the unshakable belief in the righteousness of his cause, by the faith that the people would rally around him when it came to a crisis. Now, standing on a windswept hill with a few poorly armed farmers and mechanics, little food and none of his legislators present, the crisis had come.

Strapping a pair of gun belts across his chest, he called his men together. He probably realized that the situation called for a rousing St. Crispin's Day speech, and he needed it as much as they did. Once again, we do not know exactly what he said but can piece it together from what others later said about the scene.

He had come to reconvene the people's legislature, and to carry the people's constitution into effect, and for no other reason than that. The men encamped on the hill were to guard the legislators and government officials from any Algerine attack. They were here as a defensive force, not an offensive one. He dismissed the talk of men arriving from other states, adding that he would only call upon the aid he had been promised if there was any attempt by the federal government to intervene on behalf of the Algerines. He instructed his men that the people of Chepachet must not be mistreated in any way, and their private property must be given great respect. When he later learned that some of the men had taken a cow from a local farmer and roasted it for supper, he paid the farmer out of his own pocket.

He concluded by swearing that he would rather leave his bones whitening upon Acote's Hill than deny the people their rights.

Jedediah Sprague's tavern was just down the road from the hill, and he offered it to the governor for his headquarters. Dorr spent his time going back and forth between the tavern and the camp, issuing orders and meeting with his advisors. Late in the day on Saturday the twenty-fifth, probably about the same time that the General Assembly was declaring martial law from Newport, Dorr issued two proclamations of his own.

> *State of Rhode Island and Providence Plantations*
> *A Proclamation, by the Governor of the Same*
> *By virtue of the authority vested in me by the constitution, I hereby convene the General Assembly...at the town of Glocester...for the transaction of such business as may come before them.*

The Dorr War

And I hereby request the towns and districts in which vacancies may have occurred by the resignation of representatives or senators, to proceed forthwith to supply the same by new elections, according to the provisions of the constitution.

Given under my hand and seal of state, at Glocester, the 25th day of June, A.D. 1842

<div align="right">THOMAS W. DORR</div>

General Orders
Headquarters, Glocester, RI
25, 1842

I hereby direct the military of this state who are in favor of the People's Constitution, to repair forthwith to head quarters, there to await further orders; and I request all volunteers and volunteer companies so disposed to do the same.

It has become the duty of all citizens who believe that the people are sovereign, and have a right to make and alter their forms of government, now to sustain, by all necessary means, the constitution adopted and established by the people of the state, and the government elected under the same.

The only alternative is an abject submission to a despotism, in its various practical effects, without parallel in the history of the American states. I call upon the people of Rhode Island to assert their rights, and to vindicate the freedom which they are qualified to enjoy in common with other citizens of the American republics.

I cannot doubt that they will cheerfully and promptly respond to this appeal to their patriotism and to their sense of justice, and that they will show themselves in this exigency to be worthy descendants of those ancestors who aided in achieving our national independence.

<div align="right">THOMAS W. DORR
Governor and
Commander-in-chief</div>

He set aside his pen and settled back in his chair, letting the ink dry. The people would come. He knew they would. They had to. He could feel it in his bones.

On Sunday afternoon, Dorr had a tense interview with Dutee Pearce, a longtime supporter who had accompanied him on the fruitless mission to Washington. But now Pearce came to Acote's Hill to plead with his friend to give up this obviously hopeless cause.

Acote's Hill

Pearce warned that a heavily armed force was about to march from Providence to attack, probably on Wednesday. Dorr countered that "when they started from Providence, enough of his friends there, who had not come out, would hang about their skirts, so that when they reached Chepachet they would be inefficient."

Pearce could not agree. When he asked how many men Dorr had under his command, he received "no definite answer."

Pearce informed Dorr that the Algerines had called for a new constitution, "under which all could vote for delegates, and that this measure tended in great measure to allay the excitement, and that many of those who were his friends were quite willing to accept this proposition as a compromise of the difficulties."

Pearce realized there was nothing more he could say and rose to leave. Dorr quietly asked if he had resigned his seat in the people's legislature. Pearce replied that he had necessarily done so when he had been arrested in early May, one of the first victims of Algerine Law.

Monday brought a very surprising visitor out to Chepachet: Sullivan Dorr. Things between father and son had been strained, to say the least. Sullivan sometimes referred to his "poor deluded son," and there had been no visits to the family home in some time. But despite their differences, Sullivan was obviously still concerned. We don't know what was said, but it is safe to assume that the family patriarch came to plead with his son to abandon this insane enterprise, for the sake of his family name if not for his own personal safety. Thomas, of course, would not back down, and Sullivan did not remain long. But his father's words may have had an effect, and his visit may have been the last straw.

Later that same day, Dorr convened a council of war with his military advisors to review their situation. His officers felt they were in no position to defend themselves against the superior force that would be marching down on them. They were not properly armed, equipped or provisioned, and there wasn't a single professional soldier among the men camped on the hill. No one had answered his call for reinforcements, and the people's government had abandoned him. He was forced to admit the hopelessness of their situation. It was an untenable position, indeed. He was heard to murmur that he must now fight his friends as well as his enemies, bitterly adding that he would not fight on behalf of those who would not fight for him.

Dorr made what must have been the hardest decision of his life and gave the order to disband the army.

He had to get everyone out of there before the Algerines came crashing down upon them. His father had spoken of "strife attended with bloodshed

and murdering" some months ago, and now he had to make sure that didn't happen on Acote's Hill.

Taking up a pen, he dashed off the order, which was quickly conveyed over to the men on the hill:

> *Glocester, June 27, 1842*
> *Believing that a majority of the people who voted for the constitution are opposed to its further support by military means, I have directed the military here assembled be dismissed.*
>
> *I trust no impediments will be thrown in the way of the return of our men to their homes.*
>
> <div align="right">*Yours,*
T.W. Dorr</div>

He wrote to Walter Burges, a lawyer and good friend, asking him to hand deliver a message to the editor of the *Providence Express*, the daily edition of the *New Age* newspaper, and see that the enclosed notice was published in the next day's edition:

> *Glocester, R. I.*
> *June 27, 1842*
> *To the publishers of the* Express, *Providence, R.I.*
> *Having received such information as induces me to believe that a majority of the friends of the People's Constitution disapprove of any further forcible measures for its support; and believing that a conflict of arms would therefore, under existing circumstances, be but a personal controversy among different portions of our citizens, I hereby direct that the military here assembled be dismissed by their respective officers.*
>
> <div align="right">*T.W. Dorr*
Commander-in-Chief</div>

He handed the notice and note over to one of his men, with instructions to deliver them to Burges in Providence immediately. Out on Acote's Hill, the dismissal order was given at 4:00 p.m., and "the troops dispersed in great confusion, like a flock of sheep with dogs after them," according to one eyewitness.

The dismissal of the men on Acote's Hill is another of those "if" moments in the history of the rebellion. Had Dorr chosen to remain and fight, "bloodshed and murdering" would have been the likely result. As difficult as

Acote's Hill

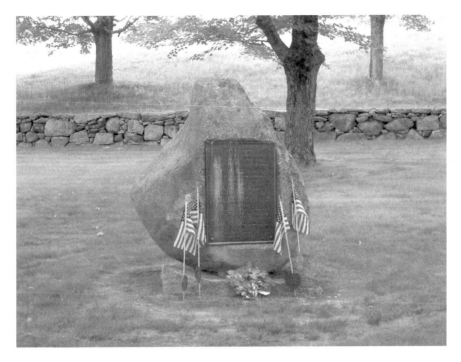

The only monument to Thomas Wilson Dorr and his struggle is this boulder on the far side of Acote's Hill. *Photo by Robert O'Brien.*

it must have been for him, he made the right decision in disbanding his men and sending them home.

Dorr himself remained for a few more hours, finally leaving the hill about 7:00 p.m., once again taking flight across the border into Connecticut and leaving behind an empty encampment under a soaking rain.

11

ALGERINE WAR

On Monday, June 27, Major General McNeil ordered his troops to move out. He placed Colonel William Brown in command of the vanguard, the strike force that would lead the attack on the Dorrite encampment. Bands played, flags flew and confidence was high that the rebellion would soon be crushed, the rebels brought to justice and law and order restored.

It was a hot day and a long march. The enthusiasm soon waned amid the sweat, aching feet and heavy packs. Reaching Greenville as it began to rain, Brown ordered the men to make a hasty camp; they would spend the night here and march the remaining few miles at dawn tomorrow to make their assault on Acote's Hill.

Dorr's messenger, carrying the papers meant for Walter Burges, had the bad fortune to stumble into a squad of Algerines on patrol and was captured. The papers were delivered to Burges in Providence by two Algerine officers about sunset. Once he had read over Dorr's order and the accompanying note, the officers handed everything over to McNeill. Why they didn't go directly to their commanding officer in the first place is uncertain. McNeill, in turn, brought the papers to Governor King. They must have been overjoyed that the Dorrite cause was lost and the crisis was over.

The notice was brought to S.M. Millard, the *Express*'s publisher, and he was ordered to print it in the next issue. He was very hesitant to do so. Just the day before, the *Express* office had been stormed by an angry mob, and a small riot ensued. One man in the crowd shouted that the whole rebellion was the *Express*'s fault, and the presses should be smashed and the types thrown into the street. Algerine soldiers on the scene confiscated anything

they considered suspect, which of course was pretty much everything. The very shaken Millard was reluctant to publish another edition without official clearance from King. This clearance was given, and Dorr's notice appeared on the afternoon of the twenty-ninth, a day later than he had intended.

In the early morning of June 28, Colonel Brown cautiously led his men toward Acote's Hill. He had not been informed that Dorr's notice had been intercepted, and the rebel camp was empty. He and his men were expecting a fight. Brown sent one of his men, Colonel Rivers, ahead with a few troops to reconnoiter the situation.

As Rivers cautiously approached the base of the hill, he encountered sixty-year-old Henry Lord, a Providence merchant who frequently passed through Chepachet on business. Stopping Lord, Rivers pointed to the several cannon atop Acote's Hill and demanded, "Will they fire?"

"No," said Lord. "There are no troops there."

Rivers must have been shocked. He and his men charged up the hill to find the Dorrite camp empty—just a few soaked tents, a broken wagon and several abandoned cannon. Rivers declared victory, arrested Lord and sent word back to Colonel Brown.

ALGERINE WAR!
CHEPACHET CAMPAIGN
Attention! Fellow Soldiers!!

Governor Dorr proclaimed a war
 Against Rhode Island's Charter:
He meant Free Suffrage should prevail,
 'T was all that he was after.

But Mr. King disliked the thing,—
 Declared a war with freedom,
And if his slaves would not submit,
 Resolved that he would bleed them.

So King drew out three thousand men
 And made a monstrous bluster;
The Algerines throughout the State
 Were called upon to muster.

And then, to show the tyrant's power,
 Proclaimed Martial Law, sir,
To bring the citizens beneath
 The harrow and the saw, sir.

But Dorr sent back intelligence
 He did not mean to fight him—
Yet on they marched, with all their force,
 To show how they did spite him.

And sure enough they took the ground,
 Three muskets and a swivel,
They found it was a tarnal joke,
 And wished Dorr to the *divil*.

They spent an everlasting sum,
 And nothing have they got, sir,
So how they must go home with shame,
 And let their courage rot, sir.

In winding up my tragic song,
 And finishing my story—
Is not Rhode Island just the place
 To go and fight for glory?

An anonymous poem praising Dorr and condemning King for declaring "a war with freedom." *Courtesy of Brown University.*

The Dorr War

It had been a long, hot march from Providence, and they had spent the night camped in the rain. Now, when they should have been rounding up Dorr and his fellow conspirators, the Algerine army found nothing but an empty hilltop. The people's governor had eluded them, robbing them of their expected triumph.

Brown and his men vented their frustration by arresting everyone in sight.

Seeking to put the best face on the situation, Brown sent word of their victory back to Providence: "The village of Chepachet and fort of the insurgents were stormed at a quarter before 8 o'clock this morning, and taken with about one hundred prisoners by Colonel William W. Brown; none killed or wounded."

The *Providence Daily Journal* ran an extra, declaring:

> *Dorr Fled and his Fort Taken*
> *News has this moment arrived that the force under command of Col. Brown has taken the insurgent fortification. Dorr has fled but large numbers of his men have been captured.*

The reality was quite different. The Dorrite encampment was anything but a "fort," and only a dedicated Algerine propagandist could say that a few men running up an empty hill had "stormed" anything, let alone the "fort of the insurgents."

Brown and his men rounded up at least one hundred prisoners—some sources say twice as many—but Dorr's followers had fled the scene the day before, and the only people to be found were innocent bystanders such as Henry Lord and other lookers-on.

Whereas Dorr had ordered his men to be respectful toward the villagers and their property, the Algerines were anything but.

A squad of men approached Jedediah Sprague's tavern, Dorr's erstwhile headquarters in Chepachet, perhaps hoping to find him still there. Sprague himself met the men out front and invited them inside. One of the soldiers placed himself in the doorway, blocking entrance with his musket. Onlooker Alexander Eddy, for reasons known only to him, decided he needed to get past the new sentry and into the hotel. When the guard glanced away for a moment, possibly noticing the arrival of more troops, Eddy seized the opportunity to push the man's musket away and slip past him, into the building.

The guard was now just as convinced that Eddy must remain outside as Eddy himself was that he should be inside. Tempers flared, and the guard

overreacted, calling Eddy a "God damned rascal" and warning him to come out at once or be shot. It was a petty contest of wills...in which one contestant brandished a musket.

The rest of the soldiers now readied their weapons, and all rushed to the door, pointing their pistols, muskets and carbines at the several guests and bystanders clustered in the doorway.

"God damn it, shoot 'em down!" one of the soldiers cried.

Bravely or foolishly, Sprague stepped into the entryway and told the men to calm down. His guests were unarmed and not resisting in any way. A brief scuffle broke out, and Sprague was shoved back against the wall. One of the others slammed the door in the soldiers' faces, locking it. Things were now completely out of control, as petty posturing boiled over into a dangerous confrontation.

Sprague, not daring to open the door, ran into the next room and climbed out a window. Approaching the soldiers, he saw one by the name of Pitman down on one knee, aiming his rifle through the door's keyhole.

"For God's sake, don't you fire in there!" Sprague shouted.

"I don't care a God damn. I mean to kill somebody!" Pitman yelled back, and he pulled the trigger.

On the other side of the door, he hit George Bardine in the leg. As Bardine fell to the floor, the soldiers pushed their way in and took possession of the tavern. According to Jedediah Sprague, they were "abusive and rough in their language and behavior." Cannon were lined up outside and pointed at the building.

The soldiers proceeded to eat Sprague out of house and home, devouring food as fast as they could demand its preparation. They also took over his stables and barns, including, of course, his own horses, and helped themselves to literally tons of the feed he had in his stores. The Algerines also broke open the bar—the same bar that Dorr had requested remain closed during his stay—and passed around "cigars, wines, and ardent spirits, according to their pleasure." Sprague would late declare that "several hundred dollars' worth of property was consumed or destroyed in liquors and cigars."

In what was rather grandiosely referred to as "the sacking of Chepachet," it was seen that the Algerines' behavior at Sprague's was not at all unusual. They helped themselves to various articles of household silver, a cookstove and even a set of "lasting garters" belonging to one Ripsy Tift.

Algerine depredations were not confined to Chepachet.

In Cumberland, a band of Law and Order men forced their way into the home of Mehitable Howard about 6:00 p.m. on Tuesday, June 28. Albert

Ballou, seemingly in charge of the raid, shoved the elderly Mehitable out of his way, bruising her, before manhandling her and demanding to know where her Dorrite son was and if there was a gun in the house.

When he came back from searching the upstairs bedrooms, having discovered a gun, Mehitable simply glared at him and said, "I don't fear you, Mr. Ballou."

Ballou grabbed her again, shaking her and shouting, "Don't you know you are under martial law?"

He jabbed her with the point of his bayonet, but she pushed it away. They stared at each other in angry silence for a long moment before Ballou stormed out of the house.

"I was hurt very bad, and unable to do my work for several days after, and have never recovered from the effects of the shock upon my system," she later wrote in a sworn affidavit.

Underscoring the deeply divisive nature of the Dorr War, she commented almost in passing, "Ballou had been a neighbor of ours for near forty years."

Stories of similarly rough searches, seizures and arrests were reported around the state as the Algerines moved to root out Dorrite insurgents. Bizarrely, there was even a detachment of troops sent to Bellingham, Massachusetts, some seven miles over the Rhode Island border, to search a tavern where rebels were supposedly hiding. They entered the building after midnight, and the outraged owner demanded to know on whose authority they were acting.

"By the authority of the bayonet!" the commanding officer shouted back.

No Dorrites were found, and the officers in charge were subsequently fined. This, of course, ironically made the Algerines into what they had so loudly feared: troops invading from another state.

King's paranoia over the possibility of troops marching down on the state in support of the Dorrite cause led to one of the few fatalities during the rebellion.

The Kentish Guards were sent to Pawtucket, the town where Samuel Slater opened his mill in 1793 and sparked the Industrial Revolution. Pawtucket straddled the Blackstone River, which at that time formed the border between Rhode Island and neighboring Massachusetts; one-half of the mill town was in either state. The Kentish Guards were under orders to guard the bridge spanning the Blackstone and blow it up should a hostile invading force attempt to cross. They arranged their artillery on the Rhode Island side, stopping and questioning those few who crossed the bridge.

Algerine War

Anyone from the Rhode Island side who came out to see what was going on was immediately ordered back to his home. The guards did not hesitate to point a gun at anyone who didn't move quickly enough, but they had no control over the Massachusetts side, where inevitably a large and curious crowd gathered. Some of the crowd taunted the soldiers and even threw rocks and garbage. All the soldiers could do was glower menacingly across the river or perhaps fire volleys into the air in hopes of scattering their unwelcome watchers.

Alexander Kelby (sometimes spelled Kilby or McKilby) was a forty-year-old husband and father of eight children who worked as a dresser tender in one of the mills. His family doctor described him as "a rather intellectual man, and read a good deal; I often loaned him books. He was a man of good character, and always peaceable and inoffensive." He had no political leanings and enjoyed fishing with a small group of friends.

One of Kelby's sons went out to see the soldiers gathered across the river and had been gone for some time. Given the tensions in the air, Kelby, a concerned father, went out to look for him as the sun set.

Kelby was seen warning some young boys to stop throwing stones at the guards before bumping into a friend, Samuel Miller. As the two stood talking for a moment on a street corner, Miller saw the Kentish Guards level their rifles at them over his friend's shoulder. He grabbed Kelby's arm and tried to pull him back around the corner of a building but was too late.

The soldiers fired, and Kelby fell to the ground, dead.

"Kilby, at the time he was shot, was doing nothing to assail or provoke the soldiers...I never knew nor saw Kilby take any part in the suffrage cause," Miller later said. "I saw no persons assailing or insulting the soldiers when Kilby was killed, and knew no reason why they should have fired upon us."

Alexander Kelby was simply in the wrong place at the wrong time, and he paid for it with his life.

The next day, his funeral procession followed his coffin past the watchful Kentish Guards, standing by "with cannon loaded and matches lighted," according to one mourner. Miller's shop was broken into and ransacked by some soldiers while he attended his friend's funeral.

One Nehemia Knight idly commented, "It was a mean business to shoot Kelby," and was immediately arrested for saying so.

The following year, the Kentish Guards were given a $1,000 grant by the General Assembly, in recognition of their brave actions during the Dorr War. They used the money to build themselves a new armory, which is still their headquarters today. A gallery of notable guards is on display,

but Alexander Kelby, the man whose death purchased the building, is mentioned nowhere.

Back in Chepachet, Brown rounded up his prisoners of war and marched them back to Providence. He tied the men together in groups of eight and encouraged them to make haste with a jab of the bayonet. A number of prisoners would later complain that some of the soldiers were "negroes." Apparently, for some, being guarded by blacks simply added insult to injury.

Along the way, Job Barker, a member of the Middletown Volunteers in the Algerine ranks, got into an argument with his brother-in-law, Robert Gould, also of the Volunteers. Barker was described as "mad from the heat," and shot and killed Gould, who thereby became the second fatality of the Dorr War. As the men were brothers-in-law, it would be safe to assume that their fight had to do with anything other than the matters before them that day.

Reaching Providence, the 130 or more prisoners were stopped in front of Hoyle's Tavern, where Dorr's inaugural procession had gathered not two months before, and held the captives up to the ridicule of the crowd gathered there. The prisoners were then paraded through the streets of the city, where they were jeered at and spit upon as "Algerine ladies waved their handkerchiefs and threw a profusion of flowers from their windows upon the brave conquerors," according to one contemporary historian. Some of the crueler soldiers suggested to the prisoners that they were to be taken out behind College Hill and shot.

Many of the prisoners were held overnight in an armory before being conducted to the state prison the next day. There, at the height of summer, they were packed into tiny cells; some accounts say fourteen men were crammed into a cell measuring nine feet by seven, where they remained for weeks.

When the examinations and interrogations finally began before a board of commissioners, the men found themselves charged with various and often vague offenses under Algerine Law. Jedediah Sprague, appearing on his own recognizance, was charged with treason.

"The evidence was that, I had entertained at my home Thomas W. Dorr, and the persons associated with him." Sprague remained in jail for twenty-two days before being released. Others would remain imprisoned even longer as the trials continued through July.

A prisoner named Chappell came forward, claiming to be the traitor in the ranks who had sabotaged the cannon on the night of the arsenal attack, jamming them with wooden plugs made of pine. No one took his claim

Algerine War

Commonwealth of Massachusetts.

His Excellency *John Davis*

Governor of the Commonwealth of Massachusetts

To the Sheriff*s* of the ~~County of~~ *the several Counties* *therein* or to *his* ~~Deputy~~ *ies*, ~~and the Keeper of~~ *in this* the Commonwealth*'s* ~~Gaol, in the said County~~,

GREETING:

Whereas, it is provided, by the Constitution of the United States, that "a person charged in any State, with treason, felony, or other crime, who shall flee from justice, and be found in another State, shall, on demand of the Executive Authority of the State from which he fled, be delivered up, to be removed to the State having jurisdiction of the crime."

And Whereas, it is further provided, by an Act of the Congress of the United States of America, approved February 12th, 1793, that, whenever the Executive Authority of any State in the Union shall demand a fugitive from justice, from the Executive Authority of any other State in the Union, to which such fugitive has fled, and shall produce the evidence thereof in said Act required, and authenticated in the manner therein specified, charging the person so demanded with having committed treason, felony, or other crime, it shall be the duty of the Executive Authority of the State to which such fugitive has fled, to cause him or her to be arrested and secured, to the end that he or she may be delivered up to the authority making the demand.

And Whereas, by the Revised Statutes of the Commonwealth of Massachusetts, (Chap. 142, Sec. 7,) the Governor is empowered to carry into effect the provisions aforesaid.

And Whereas, application has been made to me, by the Supreme Executive Authority of the State of *Rhode Island* for the delivery of one *Thomas Wilson Dorr of Providence* charged with the crime of *Treason* by *Complaint* against him, (a copy of which has been duly authenticated,) and represented to be a fugitive from the justice of said State of *Rhode Island* and now ~~in~~ *within the precincts* ~~in said county~~ of *this Commonwealth* and on the report of our Attorney General, made in pursuance of the provisions of the said Revised Statutes, I am satisfied that the demand is conformable to law, and ought to be complied with:

I have, therefore, by virtue of the authority in me vested by the Constitution and Laws aforesaid, by my warrant, under the Seal of the State, authorized and empowered *Edward H. Hazard* who has been appointed by the Governor of the State of *Rhode Island* an agent to make such demand, to take the said *Thomas W. Dorr* and transport him to the line of the State, at the expense of such agent ; and I do hereby require you the said Sheriff, and your Deputies, and the Keeper of the Gaol aforesaid, and all Civil Officers within this State, to afford all needful assistance in the execution thereof; and of your doings in the premises you will make due return to this department.

In Witness whereof, I have caused the Seal of the said Commonwealth to be hereunto affixed, this *twenty-sixth* day of *May*, in the year of our Lord one thousand eight hundred and forty-*five*, and of the Independence of the United States of America, the sixty-*ninth*.

BY HIS EXCELLENCY THE GOVERNOR.

(Signed) *John P. Bigelow*

Secretary of the Commonwealth.

A warrant for Dorr's arrest, issued in Massachusetts. *Courtesy of Brown University.*

seriously, and it was suspected that he was simply trying to curry favor with the authorities and lighten his sentence.

Samuel Ward King raised the price on Dorr's head to $5,000 and again requested the neighboring states to extradite the fugitive back to Rhode Island should he be found.

On July 4, the day Dorr had scheduled for the reconvened people's legislature, the Algerines celebrated Independence Day and their victory over the Dorrites. Militias marched, bands played and General Winfield Scott, a decorated hero, the highest-ranking U.S. Army officer and a national celebrity, extended his hearty congratulations to General McNeil for triumphing over the insurgents without calling for federal troops.

"Rhode Island has covered herself with glory," Scott declared, "and may well be termed the great conservatrix of law and order."

12

Probably to Inspire Courage

In the late summer and early fall of 1842, with the people's governor in exile and prosecutions against his arrested followers continuing, it fell to women to keep the Dorrite flame alive.

Women had been active in the suffrage cause from the beginning, even though the Rhode Island Suffrage Association never for a moment officially considered extending the vote to them. Still, women were tireless advocates and organizers, and while they never seemed to raise the question in public, if would be foolish to assume they did not do so in private, quietly, among themselves.

Continuing in their organizational role, women were largely responsible for staging a series of clambakes, both in Rhode Island and in other states, in support of Governor Dorr and his cause. The clambake is an ancient New England tradition, adopted by early European settlers from the Indian tribes native to the region. Quahogs and shellfish are steamed in pits and served to the numerous attendees along with chowder and corn on the cob. The feasts could attract thousands and often featured bands or other entertainment, and politicians or others seeking public approval often stopped by to shake hands and kiss babies. These pro-Dorr clambakes served as thinly veiled political rallies, complete with portraits of the people's governor being prominently displayed and fiery speeches—often by women—being delivered.

"The men can do nothing for them directly for fear of sharing their fate," one women wrote to a friend. "Women have to do it all, for they dare not arrest us for 'treason,' as they call it. It is in their hearts to do it, no doubt, but they fear public opinion."

The Dorr War

Indeed, the fact that clambakes were traditionally family affairs, with women and children in attendance, probably stayed the Algerines' hand. These weren't "insurgents" or a band of ragtag soldiers attacking an arsenal, but a large number of friends and families gathered together at the seaside to enjoy a day of fun and shellfish. Women's strong presence at these events, both as organizers and attendees, gave the proceedings an air of respectability and decorum.

Still, there were tensions. The women putting on the various clambakes were sometimes derided as "amazons" and "old maids" by their detractors. An Algerine officer and a few of his soldiers made their way through the crowd at a clambake held on Acote's Hill in September and were confronted by Ann Parlin, one of the speakers. As the secretary of the Rhode Island Suffrage Association and the wife of a jailed Dorrite, she once advocated for the formation of an all-female battalion to fight in support of the cause. The pugnacious Parlin was outraged that Algerines would dare blaspheme the holy ground of Acote's Hill with their presence, and she ejected them from the clambake herself.

In 1843, the Benevolent Female Suffrage Association, acknowledging that many suffragists had been fired from their jobs because of their support of the cause, appealed to the state's thousands of mill girls. The society

> *recommended the ladies of the different manufacturing establishments, to associate and form societies in defense of human rights, and to enter in a mutual contract and agreement, never to work for any manufactory where any man is dismissed on account of his political opinions, be those opinions what they may.*

These and other actions by the womenfolk earned the praise of Dorr himself, who would later write:

> *And let us not forget the debt of gratitude which is so justly due to the women of Rhode Island, who, like their predecessors of early days, have in the past year done so much in the spirit of true devotion, to lighten the toils and strengthen the hearts of their brethren and associates. Their deeds of mercy were hallowed by the prayers of the poor, and will be treasured up for other days, when it will be said that they at least were worthy of success.*

In late November 1842, Rhode Islanders found themselves back where it all began as they voted on a new constitution. With only fifty-one votes cast

against it, the new constitution was adopted and declared the law of the land, remaining in effect into the twentieth century. The small number of votes against the new constitution is probably due to Dorr's sympathizers abstaining from the vote altogether.

The new document included a bill of rights, took steps toward establishing an independent judiciary, reined in the general assembly's near-unchecked power and gave blacks the right to vote. Although it reapportioned the House of Representatives more fairly, doing so according to population, it called for one senator from each city or town, regardless of population—a clause that would remain in effect until 1928.

However, it still retained the $134 property requirement for naturalized citizens. The thousands of Irish immigrants who had backed Dorr and the suffrage cause were no better off, despite all their efforts. The property requirement for naturalized citizens would remain law until 1888.

The hunt for Thomas W. Dorr continued. King demanded his extradition should he be found in a neighboring state, invoking Article IV, Section 2 of the United States Constitution:

> *A Person charged in any State with Treason, Felony, or other Crime, who shall flee from Justice, and be found in another State, shall on Demand of the executive Authority of the State from which he fled, be delivered up, to be removed to the State having Jurisdiction of the Crime.*

The governors of Massachusetts and New York agreed to hand him over if found, while the governors of Connecticut and New Hampshire refused, claiming that King was not seeking to punish a fugitive from justice but rather exacting revenge upon a political rival. When Governor Hubbard of New Hampshire, a Democrat and Dorr ally, addressed his reply to "His Excellency Sam. W. King, acting as Governor of Rhode Island," the outraged King sent it back unopened.

Although theoretically in hiding, Dorr seemed to move about with a fair amount of freedom, visiting Connecticut, New Hampshire (where he stayed with Governor Hubbard) and even Massachusetts, where there was a warrant out for his arrest. In March 1843, he made a brief, not-so-secret return to Providence, where he was seen by only a few, apparently slipping away again before he could be detained. George Thurber wrote in his diary:

> *The "Rightful Governor" is said to have honored us with a visit last night. The* Express *says that Dorr rode through the streets at 9 o'clock in an open*

> *carriage, but no one seems to have seen him. What object Tom can have in coming here is not easily seen. Probably to inspire courage. Rather a bad hand to inspire courage, he who has been foremost in so many fights.*

Dorr seems to have spent some time in Boston, possibly in somewhat reduced circumstances. Thurber saw him there. The previous diary entry was soon followed by this one on March 30:

> *This day is to be remembered as the one on which these eyes were blessed with the sight of the immortal "Gov. Dorr." Yes, 'tis true. I saw the "Rightful." "His Excellency" was sitting in the Cambridge omnibus with a flat cap on his head and that cloak around him as dignified as if he had never run in all his life.*

Elections were held in Rhode Island in April, and James Fenner became the first Rhode Island governor elected under the new constitution; he had previously held the office twice before, from 1807 to 1811, and again in 1824–31, being reelected each year. Now beginning his third term, he would become the state's longest-serving governor. A Brown graduate, Fenner was a United States senator who left Washington to take office as the new Rhode Island governor. Dorr knew him and didn't like him. Taking his fellow suffragists to task, Dorr grumbled that they "seemed to hesitate in employing the ballot-box at the vitally important election of April, 1843, as they had before hesitated to employ the cartridge-box when force had become indispensible to the safety of their cause."

George Thurber may have echoed the thoughts of many in his diary entry for April 5, 1843:

> *The long wished-for day has at length come and passed. The field has been fought and won. Dorrism is vanquished and fled, and the broad banner of "Law and Order" waves its folds over our little State. Now 'tis passed, Dorrism has no home with Rhode Island's sons—they own it not. 'Tis a triumph of law-regulated liberty over the wild revolutionary schemes of demagogues.*

Despite taking public transportation and wearing a flat cap, Dorr could not have been too bad off during his time in Boston. He issued a lengthy statement from there on August 10, 1843, giving his side of the story. Once that was published, he seemed to decide the time had come to return home,

"not in a spirit of defiance, or courting persecution, but as a Rhode Island man who had a right to be here, who desired or sought no domicile abroad, and was unshaken by defeat in the avowal of the doctrines of liberty."

On October 31, 1843, sixteen months after leaving Acote's Hill in humiliation, Thomas Wilson Dorr arrived in Providence and nonchalantly sauntered into the City Hotel downtown, asking for a room. No rooms were available, and he crossed the street to the home of Mr. Simmons, the editor of the sympathetic *Republican Herald*. He was quickly arrested in the street by Deputy Sheriff Jabez J. Potter. He was soon incarcerated in the state prison, where many of his followers yet languished, and bound over for trial. He was charged with treason under Algerine Law.

13

That Judicial Farce

One section of the Algerine Law specified that "all indictments under this act, and also all indictments for treason against this state, may be preferred and found in any county of this state, without regard to the county in which the offence was committed." This enabled Attorney General Blake to move the scene of Dorr's trial from Providence, long a Dorrite stronghold, to Newport, the seat of Algerine power. Indeed, the trial was held in the Colony House, the very building where King and his General Assembly met. Dorr's heart must have sunk even further when he found himself appearing before Chief Justice Job Durfee, the justice who, it will be remembered, had two years before declared the people's constitution to be worthless and lawless and those supporting it guilty of treason.

Samuel Y. Atwell and Walter Burges, Dorr's longtime friends and allies in the cause, offered to take the case. But once the trial began on April 25, 1844, Atwell was absent due to illness, and Dorr, no stranger to the courtroom, chose to represent himself. He must have known the old adage that he who represents himself has a fool for a client, but he went ahead anyway. He wanted his day in court. A stubborn man, he may have felt that no one could tell his story better than he could and wanted to put his case before the people—always, to him, the highest authority.

During the selection of jurors, Dorr must have realized just how thoroughly the deck was stacked against him. Out of 118 potential jurors, only three were Democrats, the party that had supported the suffrage cause. The remainder were Whigs and other Law and Order men—in other words, Algerines.

That Judicial Farce

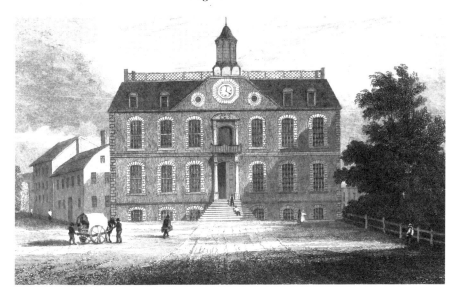

An engraving of Newport's Old Colony House, completed in 1741, where the Algerine General Assembly met and where Dorr's trial for treason was held. *Courtesy Newport Historical Society.*

One potential juror explained that the charter forces "did not kill enough at Chepachet," apparently unaware that they had not killed anyone at all. Another man grumbled that "T.W. Dorr ought to be shot," while another advocated hanging for the whole suffrage party. Still another man disturbingly asserted that if he had his way, he "would chop Dorr fine enough to make sausage meat."

Realizing the homogeneity of the jury being assembled to judge him, Dorr spoke "sportingly" to the sheriff who escorted them into the courtroom: "Give us this time, Mr. Sheriff, two or three Democrats. Before, they were all of the other sort…I repeat, let us have men on this jury who are not all of one sort."

Once the jury was empanelled, Dorr rose to argue that the trial should be held in Providence, where his alleged crimes had been committed. But he soon dropped the argument, wishing the trial to get underway.

The indictment spoke of Dorr's "wickedly and traitorously devising and intending, the peace of the said State of Rhode Island and Providence Plantations, to disturb and to stir up, move, and excite insurrection, rebellion and war," and how he led "three hundred persons and upwards, armed and arrayed in a warlike manner" into battle. The indictment concluded with a fierce allegation that "he, the said Thomas Wilson Dorr, with the persons so

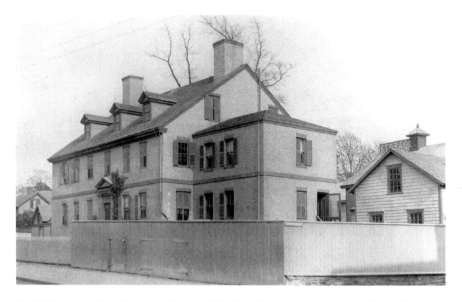

An 1890s photo of the Newport County Jail, where Dorr spent months awaiting trial. *Courtesy Providence Public Library.*

as aforesaid traitorously assembled and arrayed in manner aforesaid, most wickedly, maliciously, and traitorously did ordain, prepare and levy war against the State of Rhode Island and…against the peace and dignity of the state."

According to one account of the trial, assistant attorney Mr. Bosworth made the opening remarks for the prosecution and

> *then went on to give a history of the proceedings against the defendant, and to describe his motives and character in an exaggerated strain of denunciation and invective, more adapted to the political caucus than to the hall of justice, and which a political opponent should hesitate to employ.*

The first witness for the prosecution was called on the morning of April 30 and the last on the afternoon of May 2. Most of them were former Dorrites who had been present at the attack on the arsenal, at Acote's Hill or both. The major episodes of the Dorr War were reconstructed by the witnesses over the course of four days, and even those called to testify against Dorr spoke highly of him, praising his high-minded, if obstinate, idealism, integrity and sense of duty to the people. All who were asked insisted that Dorr had come to Acote's Hill only to reconvene the people's

That Judicial Farce

legislature and carry the people's constitution into effect; those assembled there in arms had only come to defend the people's government and would not hesitate to defend themselves against any attack, whether it be from Algerines or federal troops.

Mr. Bosworth, for the prosecution, could not agree, as he loudly condemned

> *a set of daring, worthless, desperate men, guided and directed by a leader who sought the bad eminence in which he was placed...and who waged war on the sanctities of private life, for the accomplishment of his foul, ambitious, and nefarious purposes. To attain which he was ready and willing to imbrue his hands in the blood of his friends and relatives...after having committed such atrocities he escaped from the state...*
>
> *...All of which indicated most clearly in all of them a deliberate, wicked, and malicious intent. They knew what they were about; they acted with their eyes open, and the consequences are upon their heads...*
>
> *...The prisoner returned again to the state, still bent upon his wicked object and urging others to carry it into effect, even at the sacrifice of life...a formidable force was sent to break up his encampment; and when all hope of success vanished, and he had nothing left to depend upon, he fled again, thereby manifesting a sense of guilt, and a conviction that he was a wrong doer who felt no confidence in his cause. For if he had been animated, as it has been pretended, by a sense of duty, he would have remained, to receive the justice that was due, and which he could have no reason to fear if he was not guilty.*

Bosworth closed his opening remarks by insisting that the jury "must pronounce the prisoner guilty."

With his character thoroughly assassinated before a hostile judge and a jury of Algerines, the people's governor began the case for his defense.

Mr. Turner, Dorr's chief assistant in Atwell's absence, raised the points upon which the defense was built. He maintained that treason could only be committed against the United States and not any particular state. He asserted that the Algerine Law was unconstitutional, as it provided for trials without a jury and allowed crimes allegedly committed in one county (Providence, for instance) to be tried in another (for example, Newport). Finally, there was what Turner described as "the right arm of our defense"—"that the defendant acted justifiably, as Governor of the

State, under a valid constitution, rightfully adopted, which he was sworn to support" and that there was absolutely no evidence of treasonous or criminal intent on Dorr's part.

Condemning the charge of treason itself, Dorr said:

> *The offense charged is political, not against individuals but against the state, under a system now no longer existing. The defendant necessarily does not stand alone. He acted for others. In trying him, you try also the 14,000 citizens who voted for the People's Constitution in 1841 and who, if there be any guilt in the doctrines of '76, are guilty with him; nay, more, you will try the principles of American government and the rights of the American people; and you yourselves will in turn be tried for any wounds you may inflict upon American Liberty. You are not sitting here in one corner of a small state, out of reach of all observation; and beware that no political bias incline you to do any injustice to the defendant, by way of retribution to the party with which he is connected…and let the public have reason to believe that it has been more fair than was intended.*

The court proceeded to demolish each point the defense sought to make.

Chief Justice Durfee dismissively declared that there certainly could be treason committed against an individual state, echoing his charge to the grand jury back in March 1841. He ruled "that wherever allegiance is due, there treason may be committed. Allegiance is due to a state, and treason may be committed against a state of this Union." He would not allow the jury to hear arguments on the question.

The legality and constitutionality of the Algerine Law had already been upheld during the course of other prosecutions, and the court flatly refused to revisit the issue.

Durfee and his assistant justices would not accept that the defendant was the legal governor of the state at any point. This led to a broader argument over popular sovereignty and the people's right to form, alter or abolish their government. The court adhered to the by-now standard assertion that only the freemen, composing the body politic, could make such decisions and take such actions. Assistant Judge Staples "observed that there was a difference between people, and the people. The word 'the' must be stricken out in order to find the doctrine of government at large contended for by the prisoner."

That Judicial Farce

Dorr shot back:

> *The Declaration of Independence uses the word* governed *in speaking of those who hold the power to amend and change governments. And surely the governed take in the whole people. A non-freeholder in Rhode Island was most assuredly among* the governed, *and in many respects to his disadvantage.*

While the court was perhaps ready to believe that Dorr thought he was the duly elected governor, it would not agree that he actually was.

"A prisoner might as well set up, to an indictment of robbery, the defense that he had a natural right to the possession of the property he took from the person he robbed," Durfee commented, later adding that "it may be that he really believed himself to be the governor of the state, and that he acted throughout under this delusion. However this may go to extenuate the offense, it does not take from it its legal guilt."

The court was not the least bit amused by Dorr's offer to produce the certified ballots he still had in storage to prove that he had been elected to office by the majority of voters. It rolled its judicial eyes in annoyance when he went on to say that he would simply call all fourteen thousand voters to testify one by one.

"The numbers are nothing," Durfee said. "We must look to the legality of the proceeding, which, being without form of legal authority, is void and of no effect."

Dorr and his team said that he "hoped not to be misunderstood in having it supposed by any that he set up the defense that he acted under a mistake of law in supporting the rights of the people or his own. Very far from it—he claimed to be justified by having done what he had a right to do." Dorr himself asserted:

> *My defense before you is a justification throughout. What I did I had a right to do, having been duly elected governor of this state under a rightfully adopted and valid republican state constitution, which I took an oath to support and did support to the best of the means placed within my power.*

Dorr raised a further point:

> *The object of the People of Rhode Island was not to overthrow the government, but to continue it under the definite forms of a written*

> *Constitution; and when the new government went into effect the other rightfully ceased. Those who held on to this old government after it had been thus properly superseded, were the opposers of the government, were concerned with the work of pulling it down, and in reality committed all the treason of '42.*

He insisted that he and his friends stood in the proud tradition of "the heroes of '76," pointing out that "the convention who formed the Constitution of the United States, were not requested or authorized to perform such an act, but only to amend the Articles of Confederation." And the Constitution they drafted replaced the Articles of Confederation, just as the people's constitution replaced the royal charter..

Dorr and his assistant, Mr. Turner, spent all of Monday, May 6, making their closing arguments. Addressing the court, Dorr said:

> *Better men have been worse treated than I have been, though not often in a better cause. In the service of that cause I have no right to complain that I am called upon to suffer hardships, whatever may be the estimate of the injustice which inflicts them. All these proceedings will be reconsidered by that ultimate tribunal of public opinion, whose righteous decision will reverse all the wrongs which may be now committed, and place that estimate upon my actions to which they may be fairly entitled.*
>
> *The process of this court does not reach the man within. The Court cannot shake the convictions of the mind, nor the fixed purpose which is sustained by integrity of heart. Claiming no exemptions from the infirmities which beset us all, and which may attend us in the prosecution of the most important enterprises, and, at the same time, conscious of the recitude of my intentions, and of having acted from good motives in an attempt to promote the equality and to establish the just freedom and interest of my fellow citizens, I can regard with equanimity this last infliction of the Court; nor would I, even at this extremity of the law, in view of the opinions which you entertain, and of the sentiments by which you are animated, exchange the place of a prisoner at the bar for a seat by your side upon the bench.*
>
> *The sentence which you will pronounce, to the extent of the power and influence which this Court can exert, is a condemnation of the doctrines of '76 and a reversal of the great principles which sustain and give vitality to*

That Judicial Farce

our Democratic Republic, and which are regarded by the great body of our fellow citizens as the birthright of a free people.

From this sentence of the Court I appeal to the People of our State and of our Country. They shall decide between us. I commit myself, without distrust, to their final award. I have nothing more to say.

Attorney General Blake summed up the prosecution's case. And Chief Justice Durfee delivered his charge to the jury, in the course of which he warned them: "We know nothing of the existence of the so-called 'People's Constitution' as law, and there is no proof before you of its adoption, and of the election of the prisoner as Governor under it," thereby arguing against Dorr's justification defense.

The now very tired jury retired to deliberate about 10:45 p.m.

One juror would later admit that they "agreed upon the verdict immediately, but remained out so that the crowd might disperse to their homes."

At 1:40 a.m. on Tuesday, May 7, the jury returned a verdict of guilty against Thomas Wilson Dorr.

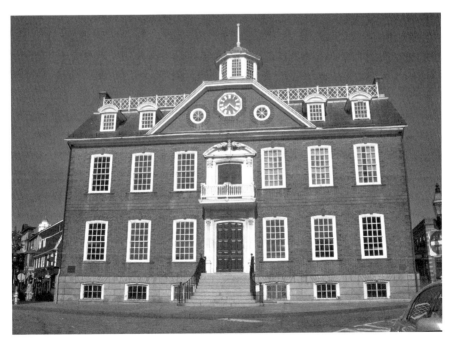

The Old Colony House still stands at the head of Washington Square in downtown Newport. *Photo by Robert O'Brien.*

The Newport jail is now an inn, the interior décor of which acknowledges the building's history. *Photo by Robert O'Brien.*

"There was nothing for us to do," another juror commented. "The court made every thing plain for us."

Dorr and his team filed a motion for a new trial, submitting a bill enumerating eighteen perceived errors on the part of the prosecution and court. These errors ranged from legal technicalities up to major oversights, such as the court's complete refusal to consider the question of whether Dorr ever acted with criminal intent. The court discounted each point in turn, and the motion was denied.

"I am bound, in duty to myself," said Dorr, "to express to you my deep and solemn conviction that I have not received at your hands the fair trial by an impartial jury to which by law and custom I was entitled."

Ignoring Dorr's remarks, Durfee imposed his sentence: "That the said Thomas Wilson Dorr be imprisoned in the state prison at Providence, for the term of his natural life, and there kept at hard labor in separate confinement."

That Judicial Farce

Dorr entered prison on June 22, 1844, consigned to what must have seemed like an Algerine oubliette.

"As soon as that judicial farce was over," a contemporary wrote, "he was immediately thrust into a filthy dungeon whose damp sepulchral atmosphere was pregnant with death."

But if they thought they had seen the last of the people's governor and the Dorrite cause as the cell door slammed shut behind him, they could not have been more wrong.

14

AN EFFECTIVE WEAPON IN POLITICAL WARFARE

"Ridicule has often been an effective weapon in political warfare," an anonymous author would write some years later, "and it has seldom been more freely employed than in the fierce contests of Rhode Island, where satire has vied with denunciation, and wit has embellished if it has not softened the rude encounters of political strife."

Beginning in January 1843, the *Providence Daily Journal* ran a two-part mock-epic poem entitled "The Dorriad," by one Henry B. Anthony. He lampooned the bungled attack on the arsenal:

> *Th' impatient chief looked on with ire,*
> *Blanched was his cheek, but tenfold fire*
> *Was flashing in his eye.*
> *He threw his martial cloak aside,*
> *And, waddling up—he meant to stride—*
> *"Give me the torch," with fury cried,*
> *"And, d---- it, let me try!"*
> *He seized the match with eager hand,*
> *While backward his brave soldiers stand;*
> *Three times he waved it in the air,*
> *The cursed Algerines to scare,*
> *And bid them all for death prepare;*
> *Then down the glowing match-rope thrust,*
> *As though he'd have the cannon burst.*
> *Had they not put the ball in first*
> *It very likely would.*

An Effective Weapon in Political Warfare

An unflattering portrait of Governor Dorr. *Courtesy of Russ DeSimone.*

> *But, hark! what sounds astound the ear?*
> *Why turns each hero pale with fear?*
> *What blanches every lip with fright?*
> *What makes each "General" look so white?*
> *And e'en the Governor looks not quite*
> *As easy as a Governor might.*
>
> *The mingled toll of twenty bells,*
> *The solemn note of warning tells;*
> *And through the ranks the word has past,*
> *"The Algerines have come at last!"*

And went on to describe the "Chepachet Campaign":

> *The Governor saw with conscious pride*
> *The men who gathered at his side;*

That bloody sword aloft he drew,
 And "List, my trusty men," he cried—
"Here do I swear to stand by you,
 As long as flows life's crimson tide;—
Nor will I ever yield, until
I leave my bones upon this hill."

His men received his gallant boast
 With shouts that shook the rocks around
But hark, a voice! Old Acote's ghost
 Calls out, in anger, from the ground,
"If here your bones you mean to lay,
Then d----n it, I'll take mine away."

Not mine to sing that dreadful night,
When, scattered in disastrous flight,
 The patriot forces left the height;
Not mine to sing that dreadful day,
When all the "people" ran away
And left the Algerines in full sway.

A small book entitled *Daw's Doings*, by an author signing himself "Sampson Short-and-Fat," appeared that year as well. It belittled Dorr and his actions harshly. The illustrations depict "Daw" ("Dorr," pronounced with a heavy Rhode Island accent) as a potbellied Napoleonic general. His henchmen have names such as Smutface, Nosebag and Rotten Potato—a spiteful reference to Dorr's many Irish supporters. Daw assembles his men to break into a toolshed belonging to "King Sam," and each volunteer has "a broomstick over his shoulder, a brickbat in his pocket, and a bottle of gin slung at his side."

"Several hands" were involved in writing *The Great Slocum Dinner*, a spoof that took aim at the suffragist clambakes. Sovereignty and clams went together, according to the account. The fictional Slocum was a supposed authority on constitutional law, and the pamphlet purported to detail a suffrage dinner held at a Providence fish market, with Slocum as guest of honor. Especially decorated for the occasion, there were portraits of Guy Fawkes, Benedict Arnold and others on display. "The plates were nailed down, the knives and forks were chained to the table, and every thing was genteel and comfortable."

An Effective Weapon in Political Warfare

An illustration from *Daw's Doings: Or the History of the Late War in the Plantations*. The Napoleonic Daw greets the arrival of the "slambang artillery," pulled by a donkey. The faces in the crowd resemble popular Irish stereotypes, and Daw brandishes a butter knife. *Courtesy of Brown University.*

Among the items on the fictional menu was "Bones de Dorr, trouvee en mont d'Acote, grilles" and various clam dishes, as "Toasts were offered: To the Hero of Chepachet, the Rightful Governor. The democracy would have gladly run him, had he not decided to run himself." Another toast was offered to Dorr and several of his legislators:

> *True patriots, they; for, be it understood,*
> *They left their country for their country's good.*

Another toast was supposedly offered up to the suffrage leader by Welcome B. Sayles, his Speaker of the House:

> *The Caesar of Rhode Island;*
> *The quick decisive mind of Dorr*
> *No chains of custom hampered;*
> *Like Caesar's, short his tale of war,*
> *He came, he saw, he scampered.*

Irish music was played, along with other tunes such as "Run, Boys, Run," "The Dorr Quickstep" and selections from an opera, *Misery Loves Company*.

An advertisement for the "Moving Diorama" on display at the Cleaveland Hall on Providence's North Main Street. *Courtesy of Brown University.*

An Effective Weapon in Political Warfare

And while not exactly satire, the most curious depiction of events was certainly John Mason's "Moving Diorama of the R. Island Revolution" in nine scenes. This seems to have been a mechanical representation of key scenes in the history of the Dorr War. Clockwork automata were popular in Europe, including one that seemingly played chess, and Mr. Mason was probably employing similar technology to "imitate with wonderful accuracy the movements of animated nature." We can only imagine what it may have looked like, but Mason's advertising promised his audiences that, among other things, "the companies are seen to march on the hill and discharge their cannon, and leave for Providence." All for an admission price of "25 cents, without distinction of age."

15
THAT ULTIMATE TRIBUNAL OF PUBLIC OPINION

Rhode Island v. Thomas Wilson Dorr was not the only high-profile court case to come out of the Dorr War. Another related legal battle, *Luther v. Borden*, even reached the United States Supreme Court.

Martin Luther was a shoemaker, part-time farmer and general Yankee trader who acted as the moderator in his hometown of Bristol during the people's elections in April 1842. Holding any office under the people's constitution, even just receiving and certifying ballots, made him liable for prosecution under Algerine Law. When Governor King declared martial law and the crackdown on suspected Dorrites began, a detachment of nine Algerines, led by Luther M. Borden, went in search of Martin Luther.

Luther, knowing the danger he was in, had been staying in Massachusetts for some time and was not home when the soldiers arrived to arrest him. The men forced their way into the house, ransacking it and wrestling with Luther's aged mother, shoving her out of their way.

Of course, each side tells a slightly different story. Borden's men maintained that they had been thorough but polite in their search, and Mrs. Luther's language had been shockingly abusive.

One of Borden's men discovered someone hiding under an upstairs bed and shouted that he had found Martin Luther. Luther's mother, knowing her son to be in Massachusetts, called back that they could have him if they had really found him. The man under the bed turned out to be a frightened hired hand.

Martin Luther returned to Rhode Island in April 1843, six months before Dorr's own return. He was immediately arrested and charged with being an

insurgent against the state. He was fined $500 plus court costs and given six months in jail. Upon being released in November, Luther brought an action for trespass against Borden.

Echoing a point Dorr also made at his trial, Luther claimed that he was a duly appointed officer of the government under the people's constitution, which had been adopted by the majority of voters and replaced the old royal charter. He in turn accused Borden and his men of being the insurgents, as they were acting on the orders of a defunct, outlaw government.

When the court, much to the surprise of no one, dismissed the argument and found Borden not guilty, Luther appealed the decision all the way up to the United States Supreme Court, his case finally being heard in 1848. He and his lawyers claimed that the charter government was illegal and invalid because it was not a republican form of government as guaranteed under Article IV of the United States Constitution.

Much as Tyler had done previously, the court sidestepped the question, ruling that this was a political question and, as such, did not come within its purview.

Dorr spent his days in solitary confinement and was kept at hard labor. The labor he was given was, strangely, painting fans. Some of the fans he painted during his incarceration are now in the collection of the Rhode Island School of Design Museum of Art. On a hot day, crammed into a tiny cell, head still reeling from a long day of breathing in paint fumes, he must have been miserable. During this time in prison, the guards would not even use his name, referring to him instead by his cell number; he was merely Number 56. He was allowed neither visitors—not his friends, not his lawyers, not even his parents—nor letters. Because of this, he was prevented from ever filing papers to appeal the court's decision to the Supreme Court.

George Thurber visited the prison in October; touring prisons was a regular nineteenth-century pastime. He recorded the event in his diary:

> *We were allowed a permit to visit the State Prison. The prisoners were in a workshop seated at little tables where they were at work painting fans. All sat facing the overseer, who was under an elevated seat. Among the convicts was the "patriot" Dorr, who in his parti-colored pants, half black and half gray, was at work like any other convict and seemed for once in his life to be making himself useful. We have seen this man under different phases. We have seen him the wily demagogue haranguing the dear "people" with his radicalism, the usurping ruler as he rolled in his car of state clothed with*

The Dorr War

self-constituted dignity, and as a fugitive from justice in a neighboring state, but none of these situations did he become so well as that which he now fills where he is at work for the good of the state.

Despite the fact that he was denied contact with the outside world, he did somehow manage to carry on a correspondence with Walter Burges, writer Catherine Williams and his parents. We do not know how he managed to sneak letters to them out of the prison or how their letters to him were smuggled in. Through Burges, Dorr kept apprised of Martin Luther's progress through the courts and offered advice. Catherine Williams, a longtime friend and supporter, was a writer active in the suffrage cause from the beginning; through her, Dorr stayed informed of the latest news of the movement. And despite their obvious differences, Sullivan and Lydia Dorr still cared about their son.

Outside the prison walls, attitudes were changing, and sympathy and support for Dorr grew. The Algerine government had depicted him as a deluded rebel, but its harsh treatment of him transformed the prisoner into something much more powerful and dangerous to its authority: a martyr.

The Dorr Liberation Society sold "Liberation Stock," raising funds to finance bringing the case before the Supreme Court.

Sullivan and Lydia Dorr petitioned the General Assembly for their son's release. Zecheriah Allen, an uncle on his mother's side, wrote to the governor

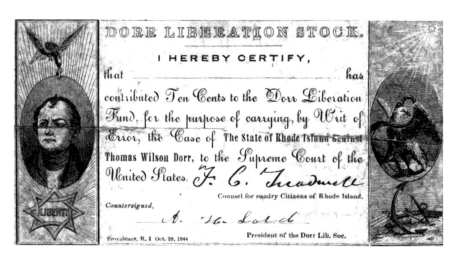

Ten cents of Dorr Liberation Stock, sold to finance an appeal to the United States Supreme Court. *Courtesy of Russ DeSimone.*

to request Dorr's discharge because, he said, his nephew was clearly insane. After some discussion and debate, it was decided, in January 1845, to offer Dorr his liberty…on one condition: he must take an oath of allegiance.

> *I do solemnly swear (or affirm) that I will bear true faith and allegiance to the State of Rhode Island and Providence Plantations; and that I will support the constitution and laws of this state, and of the United States, so help me God (or, this affirmation I make and give under the peril and penalty of perjury).*

Dorr must have been outraged at the very suggestion. He refused to take the oath and was probably also appalled that the General Assembly remained powerful enough to release prisoners at their whim.

His release became an issue during the gubernatorial race of 1845, and Fenner lost his office to Charles Jackson, who favored Dorr's liberation. He and the new General Assembly, dominated by many who likewise advocated Dorr's release, took steps toward granting him his liberty.

On May 24, 1845, the *Republican Herald* reported:

> *We learn that the parents of Governor Dorr, on Thursday last, availed themselves of a permission to visit their son in prison, and they found him in a very bad state of health.*
>
> *We have also learned from other sources, that the maladies with which Governor Dorr has been afflicted, since his imprisonment, have been increased of late, and little or no hope can be entertained of his long continuance in life, unless he shall be speedily relieved from prison.*

On June 27, 1845, after Dorr had served a long year in prison, the General Assembly passed "An Act to Pardon Certain Offenses Against the Sovereign Power of this State and to Quiet the Minds of the Good People Thereof." While the act did not mention Dorr by name, it was drafted specifically with him in mind. Later that same day, the ailing people's governor stumbled blinking out into the sunlight and open air, a free man.

Dorr was greeted by a cheering crowd; conservative newspapers insisted it was a smaller crowd than the "radical" papers reported. Several cannon on Smith Hill and nearby Federal Hill were fired in salute as Dorr, aged beyond his years, greeted the crowd. Several men made speeches, and according to the *Providence Daily Journal*:

The Dorr War

Not everyone was happy to see Dorr liberated, and there was some backlash from diehard Algerines, such as this broadside fingering some of the politicians who had secured Dorr's release as traitors. *Courtesy of Brown University.*

> *Dorr also made a speech of about fifteen minutes, in the course of which he said that he noticed there many honest faces and brawny arms, which it gave him pleasure to see, but he regretted to say that he had not seen them on a certain occasion when he required their presence much more than he did then.*

His bitterness was understandable.

George Thurber, never one to miss a chance to criticize Dorr, wrote in his diary:

> *At last the door opened and the imprisoned hero stood before us. Then off went each greasy hat and each throat found a vent and the air rang with*

> *yells so demoniacal that we might easily have imagined ourselves in the regions of the damned. But the hero heeded it not. Not a look or a nod of acknowledgement for this outburst of feeling, this display of devotion, would he grant them but, indifferent to the greetings of the people and the roar of cannon, he descended the steps and took a seat in the carriage. How his appearance gave the lie to the many stories which have been manufactured in regard to the state of his health! His face was full, his hair carefully arranged and he looked as well as he ever did. After he was seated in his carriage many of the shaveless and shirtless poked their huge paws into the carriage windows in hope the lion might lick them, but he heeded them not. "Three cheers of Governor Dorr" were called for and again the air was vocal and still the hero was unmoved.*

He was conveyed in a carriage to his family mansion on Benefit Street, a house he had not entered since 1842. Family and friends gathered to welcome him home.

Newspapers up and down the East Coast and as far away as Ohio reported Dorr's release approvingly. One-hundred-gun salutes were fired in Cambridgeport, Massachusetts, to celebrate his freedom. In Newport, supporters had planned to discharge cannon in celebration,

> *but the design was abandoned, either from the good sense of the leaders, or because they could not find any body with courage enough to touch off the cannon. In the evening, however, they returned and fired a salute, which broke the windows of the State House. The Sheriff descended to ascertain the cause of the disturbance, but the cannon, soverinnty [sic] and all, had disappeared with Chepachet rapidity.*

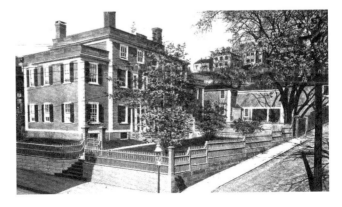

A vintage postcard view of the Dorr mansion, which still stands on Benefit Street today. *Courtesy of Russ DeSimone.*

Soon, invitations began to arrive at the family home, requesting Dorr's attendance at dinners in his honor in Hartford, New York City, Albany and as far away as Philadelphia. He politely refused each invitation, as, for a long time after his release, he was simply too sick to travel.

One letter to a newspaper editor described Dorr's condition just a month after his release from what the writer calls the "Rhode Island Bastille":

> *I found him surrounded with all the comforts and elegances which wealth or affection could bestow. But alas! The richest treasure, health, was wanting, and his countenance and feeble step betrayed disease and anguish of body, while his mind had been preserved in all its purity by a power higher than that which had so long aimed to destroy the noblest work of God. And as I contemplated that lofty brow upon which the eternal struggle of truth and justice were written, I thought the man who could wish or inflict punishment upon one like him must have a kindred spirit with the demons of another world.*

Many writers and historians have simply said that Dorr left prison a broken man and that he never quite recovered his health for the rest of his life. This only seems to be partially true. He was certainly a sick man who would continue to have health problems for years; his health ebbed and flowed, and some days he couldn't even get out of bed. After a few years, however, he recovered enough to lay plans go into the manufacturing business and take trips to Boston and New York. But the trips were draining for him, and he mostly stayed home on Benefit Street.

Still, he remained something of a name in Rhode Island politics, as he wrote to various officials offering his opinions and received letters from political hopefuls seeking his advice or endorsement. He also wrote letters to Presidents Polk and Pierce on different topics. His father or brother would often write letters to his dictation on those occasions when Dorr was bedridden. And despite his health difficulties, he acted as chief advisor and even behind-the-scenes stage manager to Martin Luther as his case played out before the Supreme Court. Dorr may have hoped that the court's decision would finally vindicate the people's cause once and for all, but he was again disappointed.

The death of former governor Samuel Ward King on January 10, 1851, must have brought a bitter smile to Dorr's face. Also that year, the General Assembly restored his civil rights. As a convicted felon, he had been unable

That Ultimate Tribunal of Public Opinion

An election broadside warning voters against voting for any ticket "with any Dorrite upon it," showing that even after the Dorr War, resentment still lingered. *Courtesy of Brown University.*

to vote or hold public office; in fact, his legal status very much resembled the non-freeholders he had originally fought for.

In January 1854, the sympathetic General Assembly passed "An Act to Reverse and Annul the Judgment of the Supreme Court of Rhode Island for Treason, Rendered Against Thomas W. Dorr." The act deemed his conviction wrongful, improper and even illegal, and the judgment against him was "hereby repealed, reversed, annulled and declared in all respects to be as if it had never been rendered." The act further instructed the clerk of the court to write, "Reversed and annulled by order of the General Assembly" across the original record of conviction.

Thomas Wilson Dorr died at home on December 27, 1854, too young at forty-nine years of age. Today, he rests in a secluded corner of Swan Point Cemetery, near a gazebo and, ironically, not far from the grave of George Thurber, the apothecary who had criticized him so bitterly in his diary. His grave is decorated with the flags of Rhode Island and the United States and a marker designating him as the governor under the people's constitution in 1842. His epitaph reads simply, "He Died in the Faith."

While this certainly refers to Dorr's Episcopalian faith, it also acknowledges a fundamental element of his character. To the end, he believed in the

righteousness of his cause and in the rights of the people to form their own government. At Acote's Hill, he truly believed that his followers would rally to his defense, and the will of the people would be carried into effect. His beliefs were sorely tested, his hopes were dashed, but he never lost the faith that saw him through his ordeals—his faith in the people.

Just over a year before his death, he penned a succinct statement that served as his own personal Nicene Creed:

> *The Doctrine of Sovereignty—There is one over all, God blessed forever; and under Him the people are sovereign. His revealed word is the higher law, to whose principles and rules of action recourse is had by the framers of constitutions and by legislators, to impart justice and equity to political institutions. The application of these principles and rules to the constitutions and legislative acts of states, and to the men in their political relations is what has been called Democracy of Christianity. Rights are the gift of God. The definition and protection of them are the objects of just government.*
>
> *Thos. W. Dorr*
> *Providence, RI*
> *August 10, 1853*

Dorr's handwritten "Doctrine of Sovereignty," where he succinctly states his position and his faith. *Courtesy of Russ DeSimone.*

Thomas Wilson Dorr's grave at Swan Point Cemetery on Providence's East Side, decorated with flags and a medallion recognizing him as the governor under the people's constitution in 1842. *Photo by Robert O'Brien.*

Thomas Wilson Dorr was a remarkable man for his or any other age. He is as significant a figure as Roger Williams, Nathanael Greene, Anne Hutchinson and others who have schools and parks named after them around the state. He deserves more than a boulder on the far side of Acote's Hill and a short street in Chepachet named in his honor.

The Dorr War

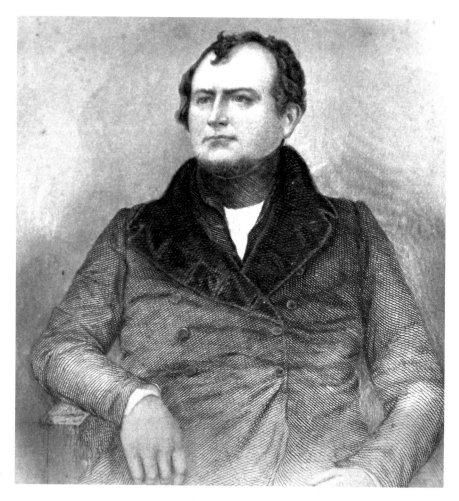

An "official" portrait of Thomas Wilson Dorr, the basis for the long-missing painting that once hung in the halls of the Rhode Island Statehouse along with the other gubernatorial portraits. *Photo by Robert O'Brien.*

(There is a Dorr Street in Providence; it is a dead end, and on my last visit, there was no street sign. And while an official portrait of Dorr was hung in the Rhode Island Statehouse some time ago, giving him his rightful place among the other governors honored there, that portrait has not been seen in many years, and no one seems to know where it has gotten to. Samuel Ward King's portrait is still on display, however. Again, Dorr deserves more.)

During the Dorr War, Dorr was hailed as the people's governor and denounced as the "Governor of Misrule." But he emerged from the hot

summer of 1842 a hero, a visionary, waiting for the times to catch up to him. He may have been denied his victory in the short term, but history has been far kinder to Thomas Wilson Dorr than his contemporaries ever were. Today we see him for the stubborn, idealistic champion of the people's rights that he was. The qualities that made him the right man at the right time also, ironically, made him the wrong man. His uncompromising idealism, unshakable faith in the people and commitment to fighting those in power, not for his own benefit, but for the betterment of others, meant that he could never be anything but a martyr. Still, he ultimately triumphed, changing the history of the state. Governor Dorr should be remembered by all who believe in that most American ideal of democracy.

Bibliography

Anthony, Henry B., et al. *The Dorriad and the Great Slocum Dinner*. Providence, RI: Sidney S. Rider and Brother, 1870.

Chaput, Erik J. "The Rhode Island Question: The Career of a Debate." *Rhode Island History* 68, no. 1 (2010).

Chaput, Erik J., and Russell J. DeSimone. "Strange Bedfellows: The Politics of Race in Antebellum Rhode Island." http://www.common-place.org/vol-10/no-02/chaput-desimone (accessed May 1, 2010).

Conley, Patrick T. "No Tempest in a Teapot: The Dorr Rebellion in National Perspective." *Rhode Island History* 50 (1992).

Dennison, George M. *The Dorr War: Republicanism on Trial, 1831–1861*. Lexington: University Press of Kentucky, 1976.

Dyer, Elisha. "Reminiscences of Rhode Island in 1842 as Connected to the Dorr Rebellion." *Narragansett Historical Record* 6 (1888).

Eaton, Thomas M. "Thomas Wilson Dorr." In *Great American Lawyers* 6. Philadelphia: John C. Winston Company, 1908.

Frieze, Jacob (Aristides). *Concise History of the Efforts to Gain an Extension of Suffrage in Rhode Island, from the Year 1811 to 1842*. Providence, RI: Benjamin Moore, 1842.

Bibliography

Gettleman, Marvin E. *The Dorr Rebellion: A Study in American Radicalism, 1833–1849*. New York: Random House, 1973.

Graham, Susan H. "Call Me a Female Politician, I Glory in the Name!: Women Dorrites and Rhode Island's 1842 Suffrage Crisis." PhD diss., University of Minnesota, 2006.

Green, Frances Harriet. *Might and Right by a Rhode Islander*. Providence, RI: A.H. Stillwell, 1844.

Kettle, Samuel (Sampson Short-and-Fat). *Daw's Doings: Or the History of the Late War in the Plantations*. Boston: W. White and H.P. Lewis, 1842.

King, Dan. *Life and Times of Thomas Wilson Dorr with Outlines of the Political History of Rhode Island*. Boston: published by the author, 1859.

Mowry, Arthur May. *The Dorr War; or, The Constitutional Struggle in Rhode Island*. Providence, RI: Preston and Rounds, 1901

Payne, Charles H. "The Great Dorr War." *New England Magazine* 2 (1890).

Pitman, Joseph S. *Report of the Trial of Thomas Wilson Dorr for Treason Against the State of Rhode Island*. Boston: Tappan and Dennet, 1844.

Providence Daily Journal, 1833.

Turner, George, and Walter Burges. *Report of the Trial of Thomas Wilson Dorr for Treason*. Providence, RI: B.F. Moore, 1844.

INDEX

A

Acote's Hill 70, 72, 73, 74, 75, 76, 78, 80, 81, 90, 93, 96, 118, 119
African Americans 30, 32, 33, 41, 45, 72
Algerine Law 44, 45, 46, 51, 52, 54, 59, 66, 68, 77, 86, 93, 94, 97, 98, 110
arsenal, attack on 13, 14, 60, 62, 63, 64, 65, 66, 67, 68, 69, 74, 86, 90, 96, 104
Atwell, Samuel Y. 23, 37, 42, 94, 97

B

blacks. *See* African Americans

C

Charles II 14
Chepachet 70, 71, 72, 73, 75, 77, 81, 82, 83, 86, 95, 105, 107, 115, 119
clambakes 89, 90
Clarke, Dr. John 15

D

Daily Express 23, 51
Dorr, Sullivan 21, 62, 64, 77
Dorr, Thomas Wilson 13, 20, 21, 23, 30, 32, 37, 41, 46, 48, 52, 53, 54, 55, 56, 57, 59, 63, 65, 69, 71, 73, 74, 75, 77, 78, 82, 91, 92, 93, 94, 95, 96, 98, 99, 100, 101, 102, 110, 111, 113, 116, 117, 119, 121
Durfee, Job 35, 36, 37, 54, 94, 98, 99, 101, 102

F

freemen 15, 16, 17, 19, 23, 24, 25, 31, 32, 34, 36, 37, 38, 42, 98

I

Irish 17, 19, 37, 38, 40, 41, 55, 70, 91, 107

K

King, Samuel Ward 23, 35, 41, 44, 45, 46, 48, 50, 53, 54, 57, 59, 60, 62, 66, 68, 69, 70, 71, 72, 80, 81, 84, 88, 91, 94, 110, 116, 120

INDEX

L

Luther v. Borden court case 110

N

nativism/nativists 37
New Age newspaper 23, 25, 34, 44, 49, 51, 78

P

people's constitution 29, 30, 31, 34, 37, 38, 42, 44, 45, 54, 70, 75, 76, 78, 94, 97, 98, 100, 101, 110, 111, 117
People's Convention 28, 29, 32, 34, 35, 36, 45, 47
Providence Daily Journal 31, 49, 51, 52, 59, 62, 68, 82, 104, 113

R

Rhode Island Suffrage Association 23, 31, 46, 89, 90
royal charter of 1663 14, 15, 16, 18, 25, 29, 31, 34, 36, 48, 50, 54, 59, 60, 111

S

sovereignty 27, 36, 37, 49, 52, 98

T

Tammany Hall 54, 55, 56, 57
Tyler, President John 44, 45, 46, 49, 50, 52, 53, 54, 59, 69, 70, 71, 111

W

Webster, Daniel 52, 54, 69
women 31, 69, 89, 90

About the Author

Rory Raven is a mentalist who performs at colleges, clubs, corporations and private events throughout the United States. He offers fantastic mind-reading shows and lectures on esoteric subjects. When not on the road, he conducts the Providence Ghost Walk, the original ghosts and graveyards walking tour through the haunted history of Providence, Rhode Island, where he makes his home with his wife and various animals. He is the author of two previous books: *Haunted Providence: Strange Tales from the Smallest State* and *Wicked Conduct: The Minister, the Mill Girl and the Murder that Captivated Old Rhode Island*, both available from The History Press. For more information, visit www.roryraven.com.

Photo by Judith Reilly.

Visit us at
www.historypress.net